CELEBRATIONS IN ART

DANCE

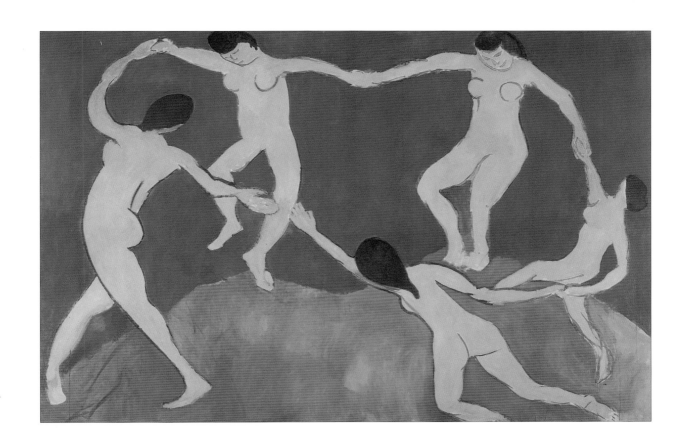

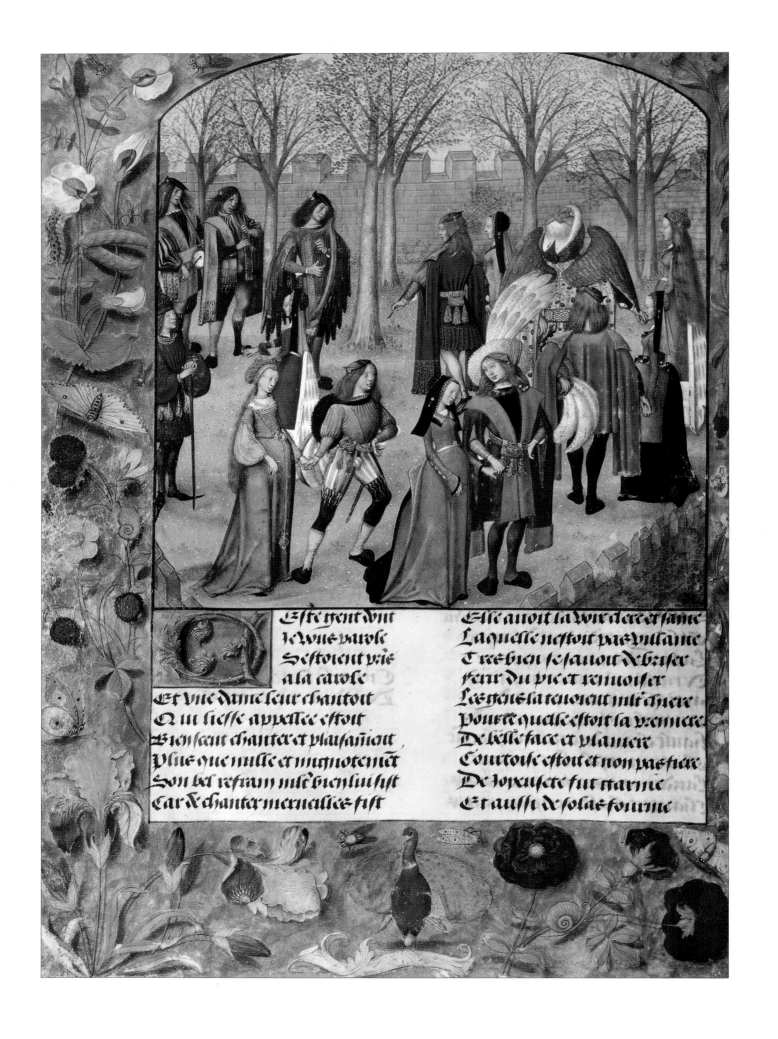

Este gent vint le vne parole
S'estoient prie
a la carole

Et vne dame leur chantoit
Qui liesse appellee estoit
Bien scent chanter et plaisaumoit
Plus que nulle et mignotement
Son bel refrain mlt bien lui sist
Car de chanter merueilles fist

Elle auoit la voix clere et sane
Laquelle n'estoit pas villaine
Tres bien se sauoit de baiser
feuir du pie et remoiser
Les gens la tenoient mlt chier
pource qu'elle estoit la premiere
De belle face et planier
Courtoise estoit et non pas fiere
De loyaulte fut garnie
Et aussi de solas fournie

CELEBRATIONS IN ART

DANCE

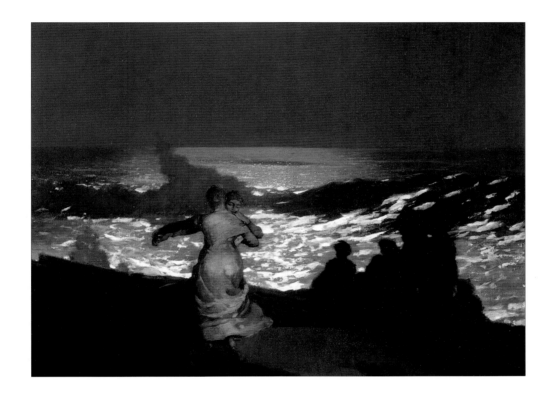

JENNIFER BRIGHT

MetroBooks

MetroBooks

AN IMPRINT OF FRIEDMAN/FAIRFAX PUBLISHERS

Library of Congress Cataloging-in-Publication Data available upon request.

ISBN 1-56799-293-5

Editor: Elizabeth Viscott Sullivan
Production Editor: Loretta Mowat
Art Director: Jeff Batzli
Designers: Lynne Yeamans and Lori Thorn
Layout: Robbi Oppermann Firestone
Photography Editor: Colleen Branigan
Production Coordinator: Marnie Ann Boardman

Color separations by HK Scanner Arts Int'l Ltd.
Printed in China by Leefung-Asco Printers Ltd.

For bulk purchases and special sales, please contact:
Friedman/Fairfax Publishers
Attention: Sales Department
15 West 26th Street
New York, NY 10010
212/685-6610 FAX 212/685-1307

Additional Photography Credits: Page 1: Henri Matisse, *Dance* (first version), 1909. Oil on canvas, 102½" × 153½" (259.7 × 390.1cm). Courtesy of The Museum of Modern Art, New York. Page 2: Master of the Prayer Books, *Dance of Mirth*, Harley Manuscript 4425, folio 14v in Guillaume de Lorris and Jean de Meun's *Roman de la Rose*, c. 1490–1500. Ink and colors on vellum, 15½" × 11½" (39.4 × 29.2cm). British Library, London. Page 3: Winslow Homer, *A Summer Night*, 1890. Oil on canvas, 29½" × 39¾" (75 × 101cm). Musée d'Orsay, Paris. Page 5: Edgar Degas, *Blue Dancers*, 1890, oil on canvas, 33½" × 29¼" (85 × 75.5cm), Musée d'Orsay, Paris. Photo: Erich Lessing/Art Resource, NY

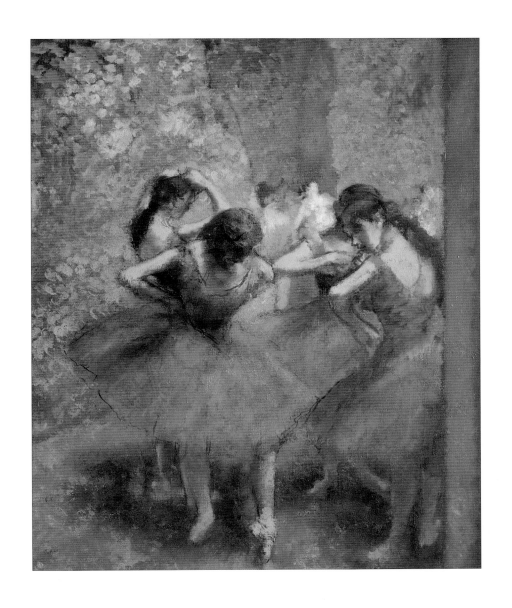

For my mother

INTRODUCTION

They who here do dancing round

are young maidens all

who will go without a man

this whole summer long.

Come, come, dear heart of mine

I so long have waited for thee.

Sweetest rosy colored mouth,

come and make me well again.

—"Reie" ("Round Dance"), excerpt from the
Carmina Burana (Songs of Beuren), 1280

Dance and music are inextricably linked. It has been hypothesized that the origins of dance were rooted in ritual. The earliest ceremony was probably a composite of patterned movement (dance), vocalization (song), and storytelling (poetry), with great emphasis on dreams and prophecy. The social origins may have evolved from the experiences of communal life, where people expressed needs and emotions either practical or spiritual in nature, like food gathering or fertility rites. Scholars believe that the first choreographed movement might have been a sort of wish fulfillment where, for example, humans might have imitated animals and mimed their capture in the hopes of later evincing those results in actuality. Prehistoric carvings and reproductions of animals of the hunt have been discovered all over the world. The fact that most of these paintings have endured is due to their placement deep in winding grottoes and caves, which supports the assertion that these were hidden sanctuaries buried in the earth, sacred sites deliberately separate from the happenings of everyday life. Throughout history

humans have been preoccupied with the question of existence—how, when, where, and why we came into being. The invention of folklore and mythology evolved in response to these universal queries, and visual art opens a path to understanding the minds and traditions of our predecessors.

The people of ancient Egypt had a rich and highly advanced culture in which ceremony figured prominently. Residences as well as final resting places were adorned elaborately with stylized murals that documented everyday activities and religious practices. According to their belief in an afterlife, the Egyptians took great pains to ensure that they would be well provided for in the land of the dead, and were buried with objects and/or symbols of things that they might need or desire later. A fragment of a painting from the tomb of Netamun in Thebes (c. 1400 B.C.), for example, portrays a banquet scene, where relatives of the deceased socialize and are entertained by a row of seated musicians and two bejeweled dancing girls.

The civilization of Greece is well known for its sophisticated celebration of the visual arts. The Greeks respected artists and their creations equally, and they were the first Western people to sign their work. Literature, theater, and dance also played an important part in Greek society, attested to by the abundant remains of amphitheaters in existence throughout Europe. In the Museo Nazionale in Naples, Italy, is a fragment of a fresco from a Greek tomb, attributed to Apulia (Ruvo di Puglia) dating from about 400 B.C. In it, eight women holding hands are performing a *tratta*, a chain dance, the steps of which are still practiced today in southern Italy.

The Romans continued the Greek veneration for the arts. Known for their magnificent murals, which were executed in *buon fresco* (pigments mixed with water which were applied before the plaster had dried), the Romans por-

trayed a variety of subjects with exceptional skill and imagination. An unusual example of this would be found in Villa

of the Mysteries (c. 50 B.C.), just outside Pompeii. The subject of the scenes is not completely understood, but it is

believed to be a depiction of some sort of initiation rites for a Dionysiac cult. Dionysus, son of Zeus, was a god of the

fertility of nature as well as the god of wine who inspired music, dance, and drama. Among the figures is a beautiful

nude woman wearing a long scarf and holding a pair of cymbals above her head as she twirls on the balls of her feet.

The art of dance faltered with the birth and development of early Christianity. Revelry and celebration became

more restrained and were limited to pious observance of strict ecclesiastical ritual in the form of meditation and prayer

rather than through physical expression. The basic vehicle of dance is the body, and the early Christian Church was gen-

erally adverse to the religious use of dance, an attitude that reflected the Church's ambivalence about the human body

itself. During this period of rejection of worldly things and extreme modesty, dance had little validity and was banished

from much pictorial art as inappropriate. There were, however, among the Christian peoples of the West, worldly dances

in which unconscious heathen attitudes persisted and through which healthy desires rebelled against the Church's

repressive control. This is proved by medieval collections of poems such as the *Carmina Burana*, which mainly consists of

love and dance poems from the twelfth and thirteenth centuries.

By the fifteenth century, during the Italian Renaissance, the separation of the sacred and the secular relaxed, as

interest in the natural sciences grew under ruling families like the Medici. Dance once more became an acceptable art

form and theme. Sandro Botticelli was one artist under the Medici employ, and his painting *Primavera* (Spring), mytho-

logical in subject, portrays Venus in her enchanted garden amid various nymphs and gods, in which the three female graces, clothed in diaphanous gowns, dance. Unfortunately, the classical sophistication that thrived in Tuscany under the Medicis was finished by the end of the century, when the Dominican monk Girolamo Savonarola, a religious, political, and social reformer, denounced the family's humanism as paganism. In Botticelli's *Mystic Nativity* (c. 1500), the artist makes an arcane reference to the difficulties of the period in a Greek inscription at the top of the painting, and appears to express a nostalgia for the Middle Ages by painting in a deliberately anachronistic way.

Elsewhere in northern Europe, in the late sixteenth through the seventeenth centuries, a gentler type of moralizing was being practiced by artists like Pieter Brueghel the Elder and Jan Steen. In the low countries, feast days of local patron saints were raucously observed during the *Kermis*, an annual festival, providing these artists with ample material for their incisive observation. Additional inspiration came from the popular theater, holy day processions that included didactic tableaux and morality plays, local folklore, and proverb books. Two different examples of peasant revelry are illustrated in Brueghel's *The Wedding Dance* (1566) and Steen's *The Dancing Couple* (1663).

While the dance movements of the lower classes were free and uninhibited, the dance steps of the aristocracy were appreciably more restrained. In the eighteenth century, a new definition of refinement and elegance presided over court dances, particularly in France and Italy, and this was reflected in the visual arts. Antoine Watteau, one of the greatest painters of the time, established a new painting genre called *fêtes gallantes*—fanciful scenes of well-dressed men and women enjoying themselves out-of-doors in parks and gardens. Watteau's style influenced many important European

artists, including his disciple Nicolas Lancret, Giandomenico Tiepolo, and Francisco de Goya y Lucientes. Watteau's extravagant influence did not extend to Great Britain, but English propriety and good manners couldn't escape the scrutiny of artists like William Hogarth, who exposed any traces of hypocrisy in his pictures of social satire. One person in Hogarth's circle, Francis Hayman, was especially known for his painted interpretations of the British theater and dance.

The late eighteenth and early nineteenth centuries in Europe were marked by a Neoclassical style of painting, which developed a more romantic quality by midcentury, exemplified by the Pre-Raphaelites. The Pre-Raphaelite Brotherhood first formed their society in 1848. A group of English painters and poets—William Holman Hunt, John Everett Millais, and Dante Gabriel Rossetti were among the first members—the Brotherhood rebelled against the routine and uninspired art of the Victorian academic school and found inspiration in the art of the Italian Renaissance. Their sometimes decorative and sentimental, sometimes otherworldly painting style was an appropriate vehicle to convey an expressive subject like dance. In France, the more contemporary-minded Edgar Degas found a world of material in dance performance. He spent countless hours sketching backstage at the ballet in Paris, where he would study the anatomy of dance, as well as that of the dancers.

Dance as art hit its peak in Europe near the turn of the twentieth century, and was depicted via a variety of mediums, particularly prints and paintings. The public dance halls of Montmartre in Paris attracted great numbers of artists, local folk, and tourists, who went regularly to see stars with colorful names like La Goulue ("the glutton"), Grille-d'Egout ("sewer grating"), and La Mélinite ("melinite," a powerful explosive), to name a few. Artists like Pierre-Auguste Renoir and, later, Henri de Toulouse-Lautrec and Georges Seurat immortalized flamboyant dances of the Parisian nightlife like the cancan and the quadrille

in their paintings. Like dance during this period, art continued to develop in exciting directions. Expressionist painters like Norwegian Edvard Munch and German Emile Nolde strove to reveal their inner emotions through their paintings, bringing a fresh intensity to their subject matter. Concurrently, in Italy, the Futurists based their artistic philosophy on the dynamics of movement in the modern world.

The twentieth century heralded vast economic and sociologicial changes that affected the collective psyche of people the world over. In the United States, the Great Depression was a time of desperation that prompted a mood of escapism, which was somewhat alleviated (and exploited) by entertainment factories like Hollywood, which provided a temporary relief from reality through film. During this time, dance marathons were a fashion craze, and live performance shows like burlesque flourished. An entire generation of urban observers, including artists like Reginald Marsh and Ben Shahn, followed an impulse toward realism in their pictures of city life.

Not thirty years later, the art trend became dramatically different and profanely irrevent. Pop art—which simultaneously orig-inated in London under the name the "New Realism"—came into being in the United States, with American artists like Andy Warhol, Roy Lichtenstein, and James Rosenquist stealing the attention away from their British contemporaries. Flagrantly commercial imagery and deliberate emphasis on a impersonal plasticity of form forced society to reassess its values and take a hard look at what constituted personal success and happiness, as well as good and meaningful art. Following a long established tradition, contemporary artists of different disciplines have continued to collaborate and contribute to each other's creations, like the prolific trio of the late avant-garde musician John Cage, choreographer and dancer Merce Cunningham, and visual artist Jasper Johns. Johns' *Dancers on a Plane* series is one product of their collective efforts, where the sensibilities of music, dance, and painting temporarily merged into one unusual and fantastic experience.

ANDREA MANTEGNA

Parnassus

1497

TEMPERA ON CANVAS, 59¼₆" × 75⁹⁄₁₆" (150 × 191.9CM). MUSÉE DU LOUVRE, PARIS.

Andrea Mantegna (1431–1506), one of the leading quattrocento (fifteenth-century) painters of northern Italy, was the official court painter to the Gonzaga family of Mantua for nearly fifty years. About 1491 the Marchesa Isabella d'Este, wife of Marchese Gianfrancesco Gonzaga, determined to create a private retreat where she could entertain her closest friends and house her considerable art collection. The Marchesa engaged many prominent artists of the Italian Renaissance for her project. *Parnassus*, the first painting Mantegna created for these apartments, depicts the lovers Mars and Venus, perched atop a natural triumphal arch, presiding above the grove of Mount Helicon. Next to the pair is their mischievous, dart-shooting child, Cupid, whose target is Venus' betrayed husband, Vulcan, seen gesturing madly in his cave. On the ground, flanked by Mercury and Pegasus, the nine Muses (personifications of the liberal arts) dance to the music of Apollo's lyre. The colors of Mars' garments, Venus' scarf, and the settee's fabric represent the combined colors of the d'Este and Gonzaga families. The subject matter of *Parnassus*, and the Muses in particular, symbolically alludes to the refinement and patronage of the Marchesa as well as the enlightened spirit of her court.

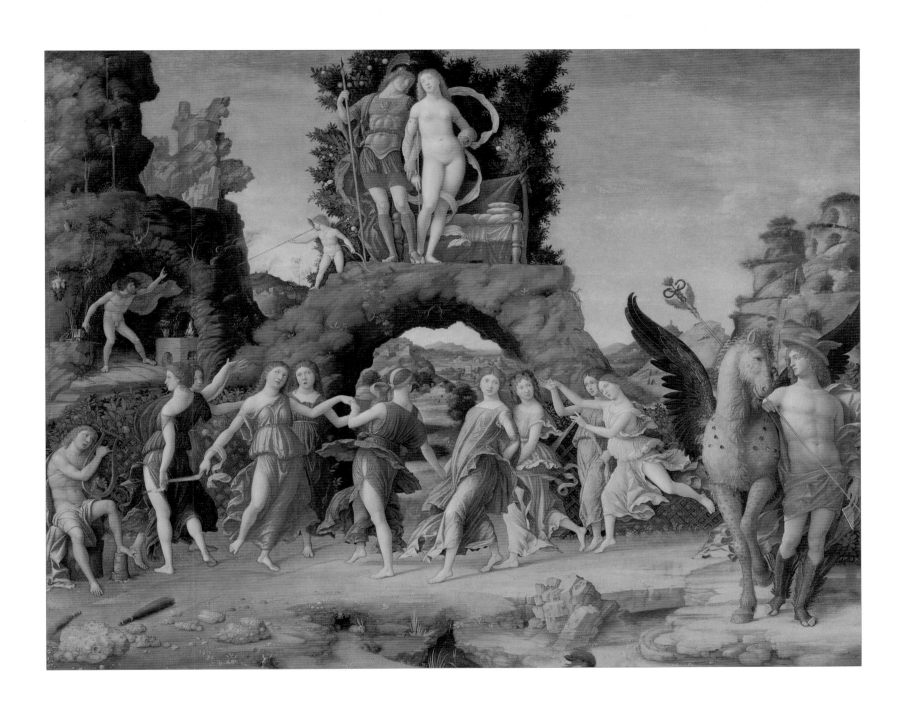

SANDRO BOTTICELLI

Mystic Nativity

c. 1500

OIL ON CANVAS, 42¹¹⁄₁₆" × 29½" (108.4 × 74.9CM). NATIONAL GALLERY, LONDON.

The Harley *Roman de la Rose* is one of about 250 known manuscripts—most of which date from the fourteenth and fifteenth centuries—that relate a popular medieval allegorical poem of chivalric love. Elaborately illustrated, this particular manuscript was hand-lettered and painted by a Flemish master. Each illuminated page is uniquely decorated and richly colored. The poem itself was begun about 1220 by Guillaume de Lorris (D.C. 1240)—who wrote four thousand of its twenty-two thousand lines—and completed by Jean de Meun (c. 1240–before 1305) later in the century. The dreamlike poem tells the story of the Lover and his quest for the Rose, the symbol of romantic love. On the page shown here, where graceful couples promenade accompanied by minstrels, the Lover is shown standing at the far left, as a lady approaches him to dance. Sir Mirth and Gladness lead the stately procession, followed by the winged god of Love with Beauty, Lady Wealth with a squire, Lady Largesse with a knight, and, finally, Candor with a knight.

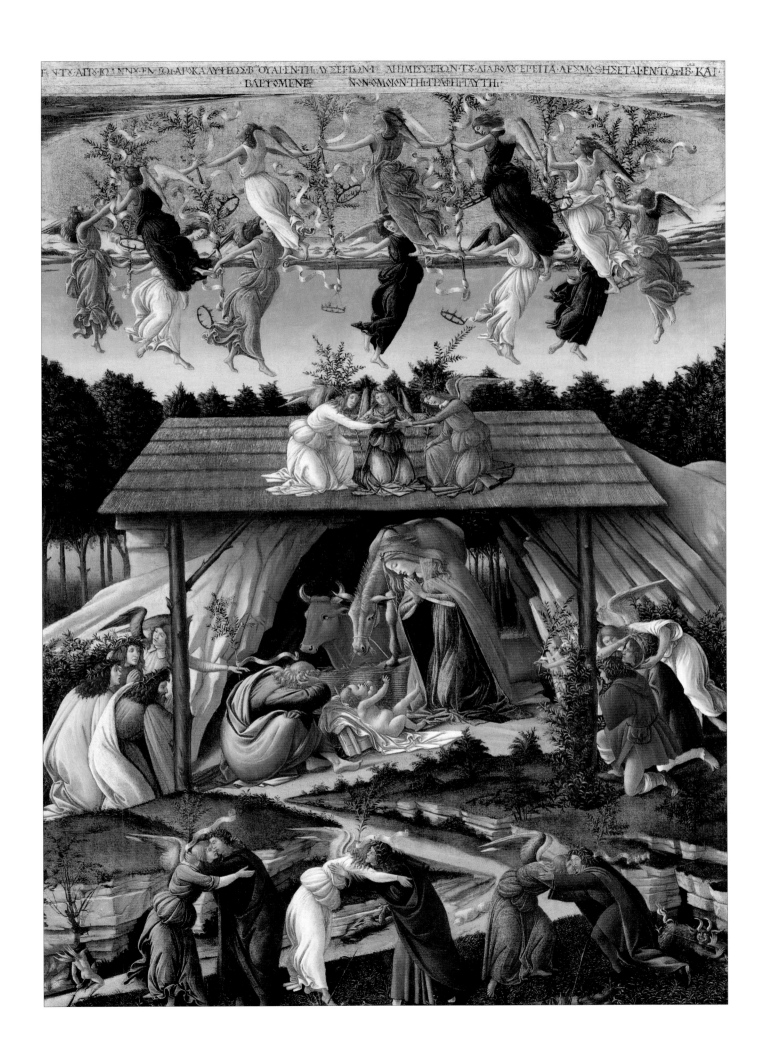

PIETER BRUEGHEL THE ELDER

The Wedding Dance

1566

OIL ON PANEL, 47" × 62" (119.3 × 157.4CM). THE DETROIT INSTITUTE OF ARTS.

The Wedding Dance by Pieter Brueghel the Elder (c. 1525–1569) is one of the artist's many compositions depicting Dutch peasant life and customs. In this painting, an outdoor wedding party is charged with the energy of a swirling country dance. About 125 figures wind through the space, weaving a complex tapestry of movement and color that Brueghel cleverly brings to a crescendo by leading the viewer's eye from the dense background to the more open, looser foreground. The rhythmic pattern of the moving figures is contained by the two sentinel figures of the bagpipe player at the right and the onlooker at the left. Having abandoned her seated position under the white crown (seen suspended on the cloth in the far distance), the young bride stands out in the scene as the redhaired girl engaged in a modest dance with a man who may or may not be the groom. Some of the guests are notably less restrained, such as the kissing couple at the near right of the canvas. Most likely Brueghel intended this last detail to be a moral admonishment against lust and wild abandon.

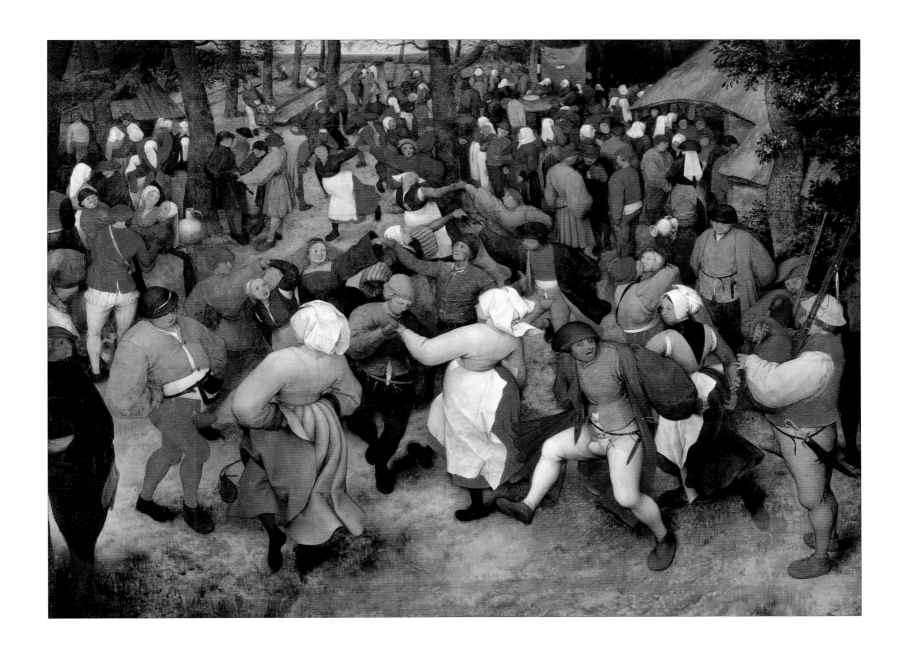

UNKNOWN

A Ball at the Court of Henri III

c. 1582

OIL ON CANVAS, 47¼" × 72¼" (120 × 183.5CM). MUSÉE DU LOUVRE, PARIS.

Attributed to an unknown sixteenth-century Flemish artist, this work is one of several paintings commemorating the festivities given in honor of the marriage of the Duke de Joyeuse and Marguerite de Vaudemont, who face front, the third and fourth from the right, at the French court of King Henri III and Queen Catherine de Médici, who stand facing front, the second and fourth from the left. The Duke, a favorite relative of the king, and his new bride's half-sister, Queen Louise de Lorraine, who are in the second row, fourth and third from the right, are joined in a formal dance with some guests in one of the Louvre's opulent chambers. The musicians playing behind them accompany their measured steps, which are marked by *cortezia*, or courtliness, a style of movement doubly dictated by their heavy, lavishly decorated costumes and their nobility of birth. The elegant interior is adorned with tapestries, and the flower-strewn floor delicately enhances the occasion. This historic painting offers a fascinating and intimate glimpse into court life of sixteenth-century France.

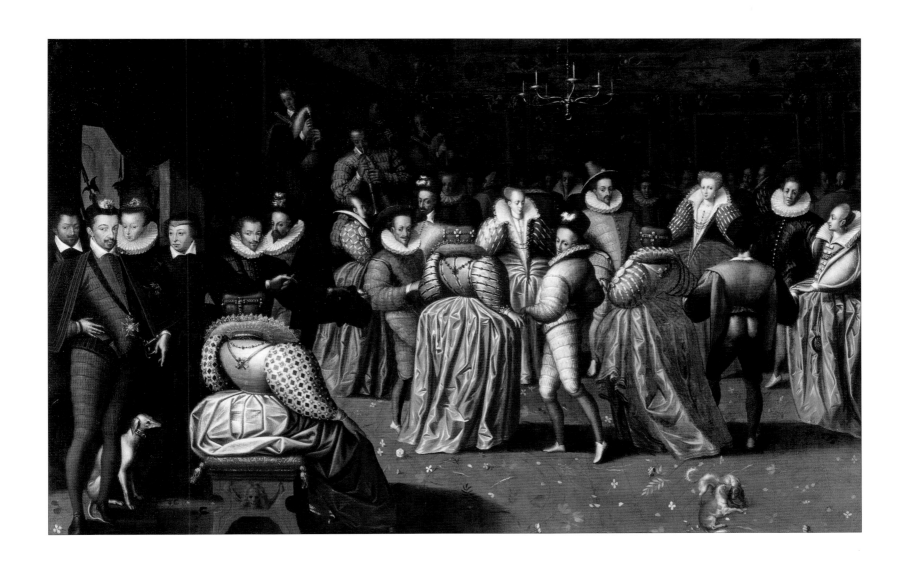

PETER PAUL RUBENS

Dance of the Villagers

c. 1636

OIL ON PANEL, 28¾" × 41¾" (73 × 106CM). MUSEO DEL PRADO, MADRID.

Peter Paul Rubens (1577–1640) was an unusually successful artist in his lifetime. Highly intelligent and cultured, he was confidential adviser and special envoy to his sovereign, the archduchess Isabella. Despite his diplomatic responsibilities, Rubens was a prolific painter. *Dance of the Villagers*, produced late in his life, pays homage to Rubens' Flemish predecessor Pieter Brueghel the Elder, but the work is entirely his own. The eight couples frolic in an idyllic Italianate landscape replete with iconographic references to antiquity, such as the animal skins and laurel wreaths worn by two of the men, and the faunlike character perched in the tree playing the flute. The disheveled revelers are dressed in neither Italian nor Flemish peasant costumes, but in clothing that reflects elements of both classical times and the upper class of the day. Broken at the right, the chain of dancers is doubled over on the left, where two couples extend handkerchiefs, making a bridge for the other dancers to pass under. Swirling in a drunken frenzy of movement, the eroticism of the painting is barely contained as a couple in the foreground twist into an embrace. Here, Rubens has infused a country romp with the spirit of a Roman bacchanal.

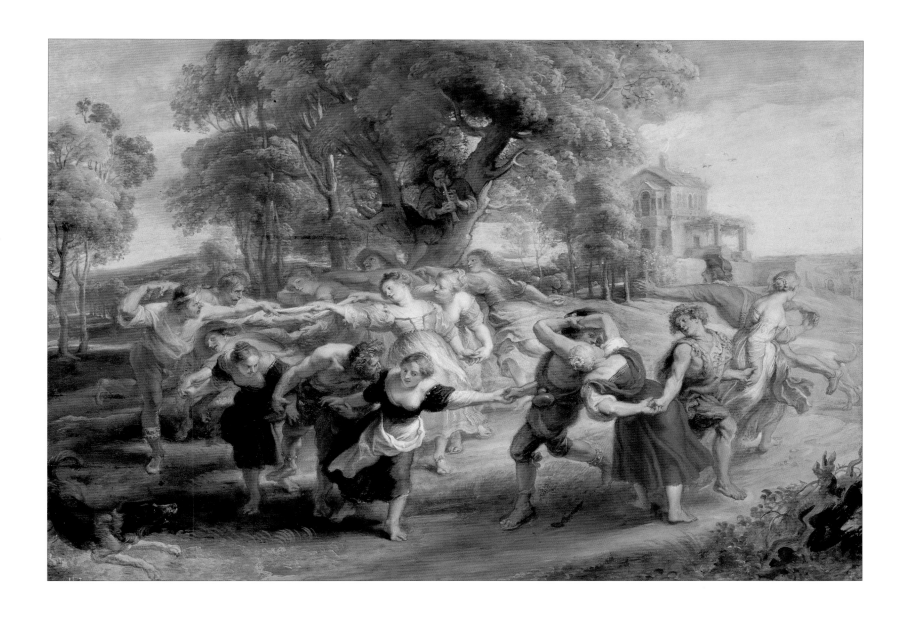

NICOLAS POUSSIN

The Dance of Human Life

c. 1638–1640

OIL ON CANVAS, 32¾" × 41⅜" (83.1 × 105CM). WALLACE COLLECTION, LONDON.

Born and trained in France, Nicolas Poussin (1594–1665) studied the Italian Renaissance and the art of antiquity. He spent most of his adult life in Rome, where, inspired by the monuments and the landscape, he established a classical style of painting expressive of French Baroque (c. 1600–c. 1750) taste. *The Dance of Human Life* is an allegory portraying the perpetual cycle of the human condition, from Poverty, the barefoot, dancing man wearing a wreath of dried leaves, to Labor, a woman whose sunburned shoulders and arms betray physical hardship, to bejeweled Riches wearing golden sandals, and, finally to Pleasure, crowned with a garland of roses. The painting's implied message is: if Pleasure is overly indulged, she will revert back to Poverty. The quartet dance to lyre music played by Time, who, with two infants, one holding an hourglass and the other blowing bubbles, symbolizes life's transitory nature. The two-headed Janus, god of gateways, surveys the passage of time, as he looks simultaneously back at the past and into the future. Moving from day into night, Apollo's chariot transits the sky, preceded by Dawn, Aurora, and dancing figures representing eight of the twenty-four hours of the day.

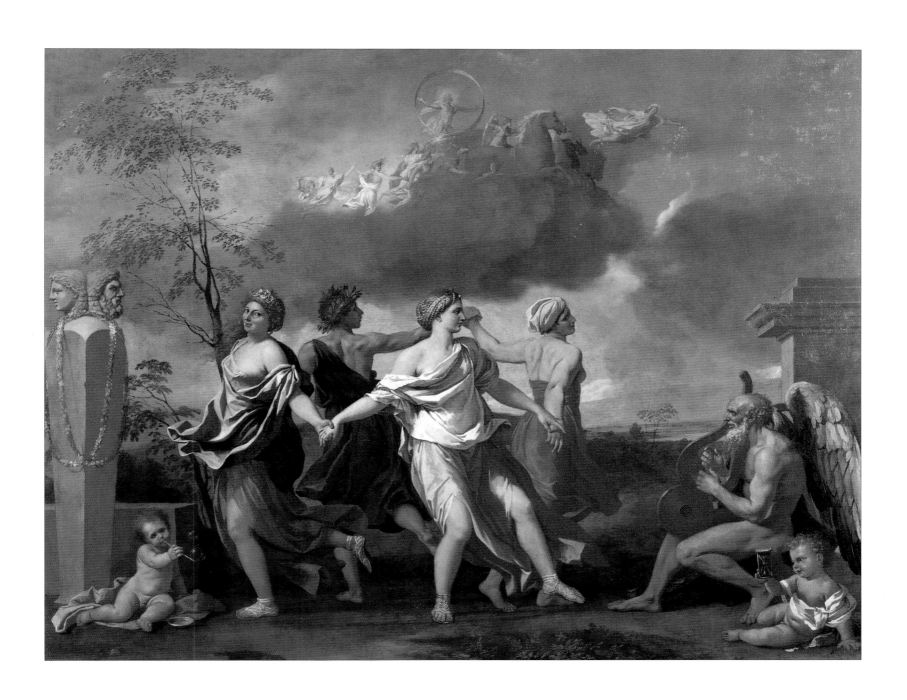

JAN STEEN

The Dancing Couple

1663

OIL ON CANVAS, 40⅜" × 56⅛" (102.5 × 142.5CM).
WIDNER COLLECTION, NATIONAL GALLERY OF ART, WASHINGTON, D.C.

The Dancing Couple by Jan Steen (c. 1626–1679) is one of many genre paintings by this Dutch artist, best known for his humorous narratives of everyday life. Under a vine-covered arbor attached to an inn or alehouse, a country celebration, probably a local fair (as suggested by the surrounding people and the tents in the distance), takes place. The banquet is set, and the guests are engaged in lively conversation, drinking, smoking, and flirting with abandon. Steen has even placed himself at the table as the laughing figure appreciatively chucking his drinking partner under the chin. But the painting's central focus is the dancing couple. Already moving to the music, a hearty man is leading a timid girl into a dance, while onlookers of all ages watch with pleasure. The innocent revelry of the scene disguises a wealth of moralistic double meaning often employed in seventeenth-century Dutch art: the caged birds in the baskets may represent virginity, and the broken eggshells, its loss. Cut flowers and soap bubbles refer to the brevity of time, and the empty wine barrel may mean that the party, like life itself, will be over too soon.

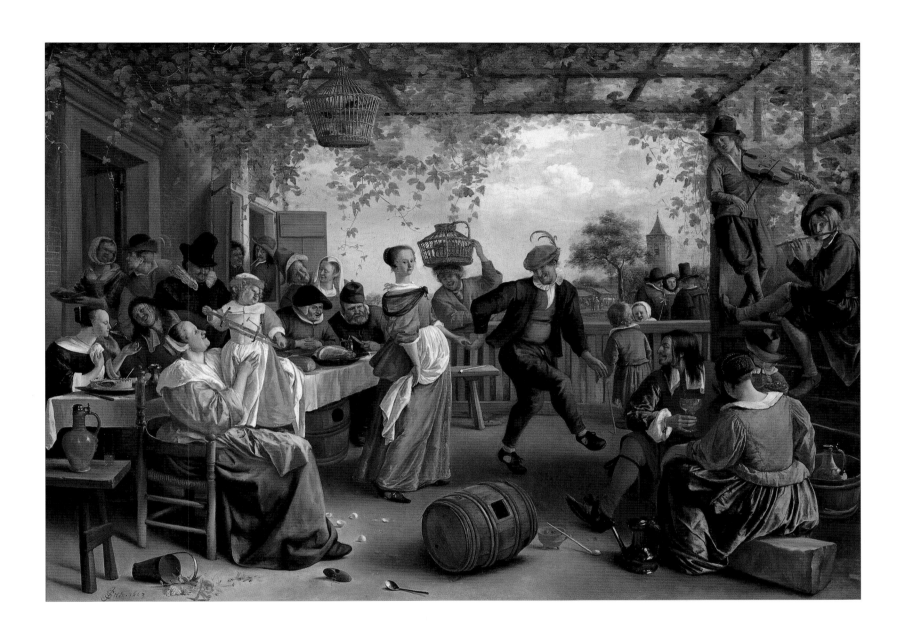

NICOLAS LANCRET

Quadrille Before an Arbor

c. 1730–1735

OIL ON CANVAS, 51⅛" × 38⅜" (129.8 × 97.4CM).
STAATLICHE SCHLÖSSER UND GÄRTEN, CHARLOTTENBURG, BERLIN.

Often overlooked or disparaged as an imitator of his friend and mentor, French painter Jean-Antoine Watteau, Nicolas Lancret (1690–1743) was a prominent and very successful artist during the first half of the eighteenth century. He was also the favorite genre painter of King Louis XV, who commissioned works from him for most of the royal residences. Lancret was one of several artists of the period who favored themes depicting the fashionable upper class at play, recording their tastes and amusements. *Quadrille Before an Arbor* demonstrates Lancret's preference for out-of-doors settings. In an elegantly equipped woods, refined ladies and gentlemen gather to enjoy an afternoon of leisurely pursuit. Two couples are engaged in a windmill dance, a type of square dance popular at the time. Behind them on a park bench, seated among various amorously preoccupied figures, is a musician playing a bagpipe. Placed on a high pedestal, a beautiful marble statue of a male nude—perhaps a representation of Bacchus, the god of wine, who would surely have enjoyed the romantic spirit of the afternoon's festivities—raising a goblet appears to survey the scene before him with approval.

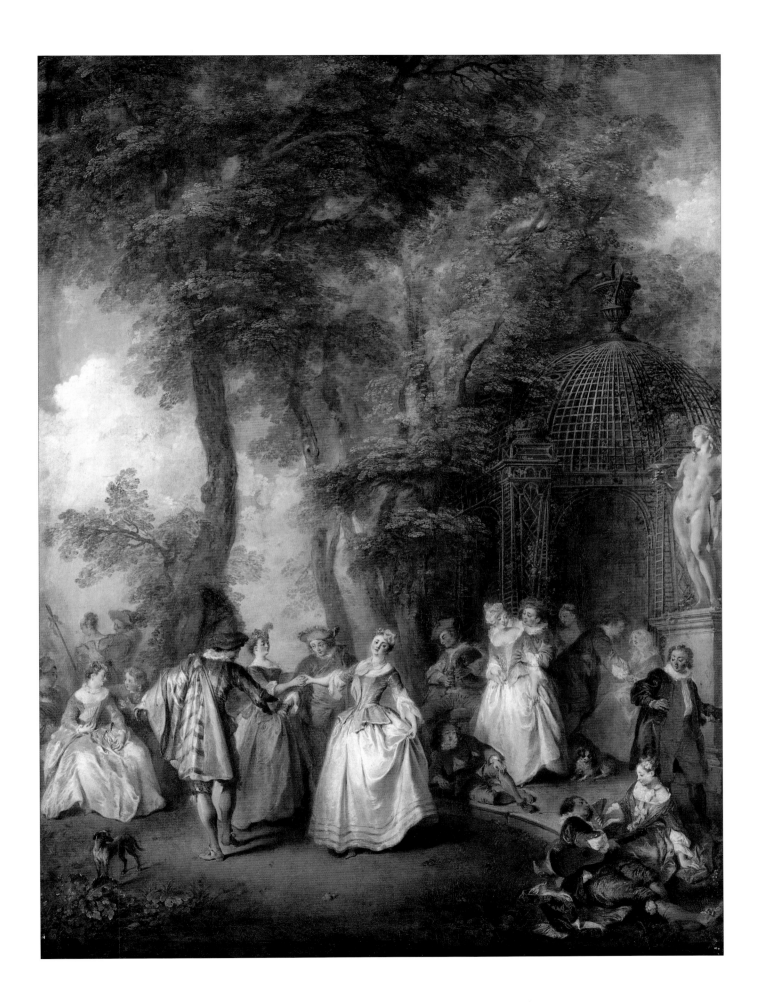

FRANCIS HAYMAN

The Milkmaid's Garland

c. 1740

OIL ON CANVAS, 54" × 94½" (137.1 × 240CM). VICTORIA AND ALBERT MUSEUM, LONDON.

One of the most versatile British artists of the mideighteenth century, Francis Hayman (1708–1776) began his career as a scenic painter. He developed a mastery of popular theatrical themes, which he also reproduced as small-scale works. Immensely respected in his time as a historical and decorative painter, Hayman was closely associated with William Hogarth and his circle, whose art works were distinguished by their informal style and subject matter. *The Milkmaid's Garland* was originally commissioned as decoration for the Vauxhall Pleasure Gardens, along with other rustic themes like *Sliding on the Ice* and *The See-Saw*. Hayman's earthy handling of this subject matter exhibits the influence of his scene painting, especially in the lack of small details and the broad, suggestive landscape. The picture's composition is made up of a series of triads and triangles, with three dancing women and three boys at a fountain, the pediment of which is visually mirrored by the roof of the building at the right. There are also three men: a peg-legged violinist, a distant, seated observer sporting a tricornered hat, and, finally, the painting's pinnacle and focal point, a merchant wearing his shining wares on his head like a crown.

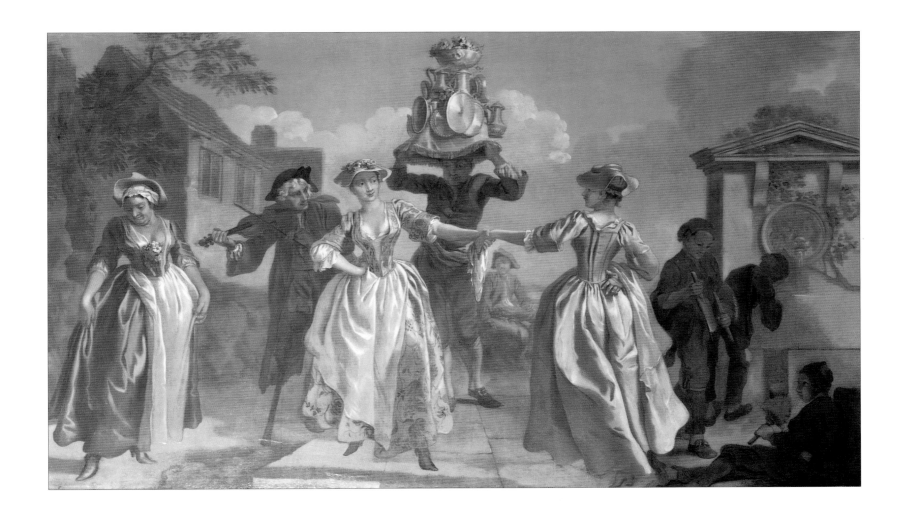

GIANDOMENICO TIEPOLO

The Minuet

1756

OIL ON CANVAS, 30⅞" × 43¹¹⁄₁₆" (78.4 × 111CM). MUSEU D'ART DE CATALONYA, BARCELONA.

"During the carnival nobody would dream of dancing unless he knew all the rules. The minuet is justly considered a work of art and few couples undertake to dance it. If a couple does so, the rest of the company makes a ring around the dancers, admires their steps and applauds them at the end." —Goethe, *Italian Voyage,* 1788

The Minuet and another work entitled *The Charlatan,* originally credited to Venetian fresco painter Giambattista Tiepolo, have been reattributed to his son, Giandomenico (1727–1804). The scene is a product of the artist's clever imagination and shrewd observation of eighteenth-century Venetian fashion combined with an instinctive appreciation of people and their idiosyncrasies. Executed in Giandomenico's crisp linear style, a couple dressed as Pantalone and Colombina, characters from the Italian commedia dell'arte theater, take center stage. As in Goethe's description, a crowd of masked revelers from all levels of society gather to watch the dance. The gentleman at the right is clad in the traditional domino costume—a black floor-length cloak and a three-cornered hat—typically worn during Venice's Carnival, the seven to ten days before Lent during which merrymaking and festivities ruled the city.

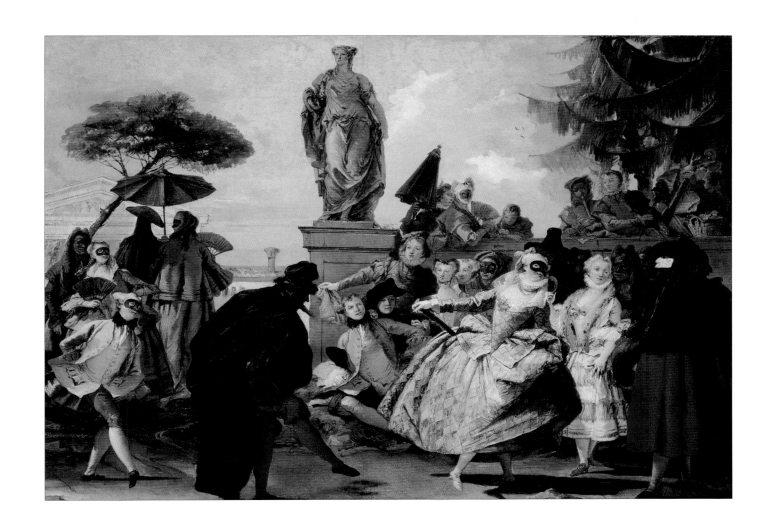

Francisco de Goya y Lucientes

Blind Man's Bluff

1788–1789

Oil on canvas, 105⅞" × 137¾" (268.9 × 359.8cm). Museo del Prado, Madrid.

In 1776 Francisco de Goya y Lucientes (1746–1828) was brought to Madrid by Danish-Bohemian Anton Raphael Mengs, who was one of King Carlos III's favorite artists as well as the director of the Royal Tapestry Manufactory. Over the next sixteen years, Goya created over sixty "cartoons," or proposed designs, that were executed as oil paintings, some of which were then transformed into tapestries by skilled artisans. The themes for Goya's designs were drawn from daily life and from his childhood memories of country living, representing a colorful diversity of Spanish life, including fiestas and dances, weddings and luncheon parties, as well as gamblers, stilt walkers, and children at play. *Blind Man's Bluff* is one of these cartoons, which were perhaps the Spanish answer to the French country festival paintings of Jean-Antoine Watteau and Nicolas Lancret and the Venetian Carnival paintings of Giandomenico Tiepolo. The freshness and high spirits of the figures in this pastoral scene hearken from Goya's youth, before hardship and disappointment molded him into the sharp-sighted and critically astute political observer who produced dark, satiric works that explored the psychological depths of human nature, war, and social injustice.

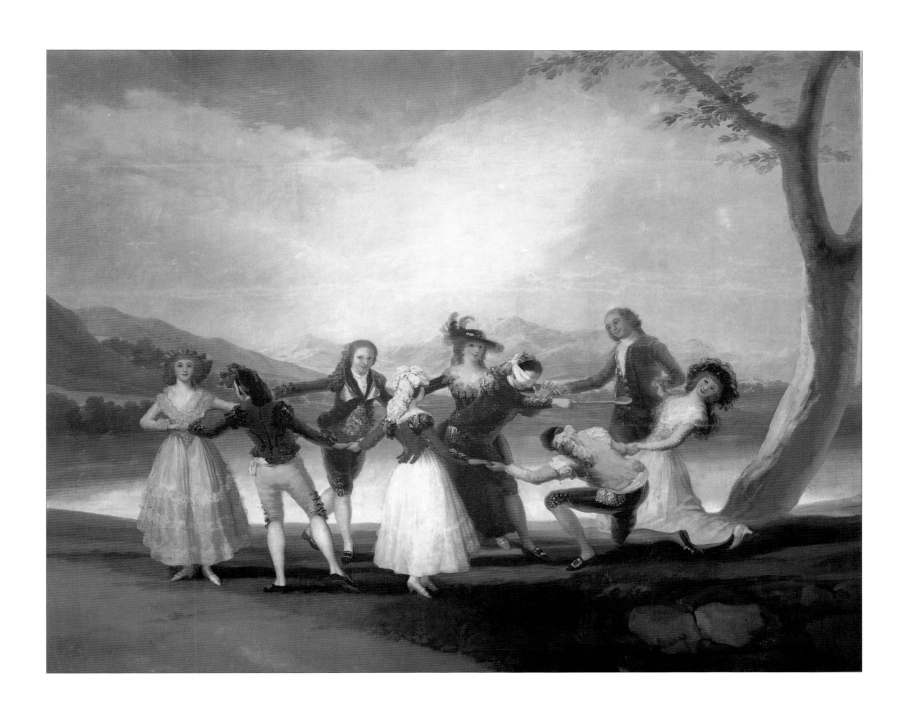

UNKNOWN

The Old Plantation

c. 1790

WATERCOLOR ON LAID PAPER, 11¹¹⁄₁₆" × 17⅞" (29.6 × 45.4CM).
ABBY ALDRICH ROCKEFELLER FOLK ART CENTER, WILLIAMSBURG, VIRGINIA.

This charming watercolor by an unknown artist is set on a plantation, possibly in South Carolina. In front of two humble wooden structures and a bending river, several African-American slaves are congregated in joyful celebration. Scholars have suggested that the painting might portray a wedding ceremony, as the act of jumping over a stick, particularly a broomstick, has been associated with certain African nuptial traditions. Other authorities assert that the movement is of a more secular nature, as dancing barefoot with sticks and scarves is common among the Yoruba people of northern and southwestern Nigeria, and the cloth headdresses have been identified as being West African in origin. The musician at the right may be playing a Yoruba *gudugudu*, a hollowed piece of wood stretched with animal skin that is tapped by tightly twisted leather strips, although he may be striking a hollow gourd with sticks or bones. The stringed instrument suggests a Yoruba *molo*, an antecedent of the quintessentially American banjo. Executed in a childlike, folk-art manner, the figures are carefully rendered and highly individualistic. *The Old Plantation* conveys a familiarity that attests to the simple pleasure derived from time spent in good company, song, and dance.

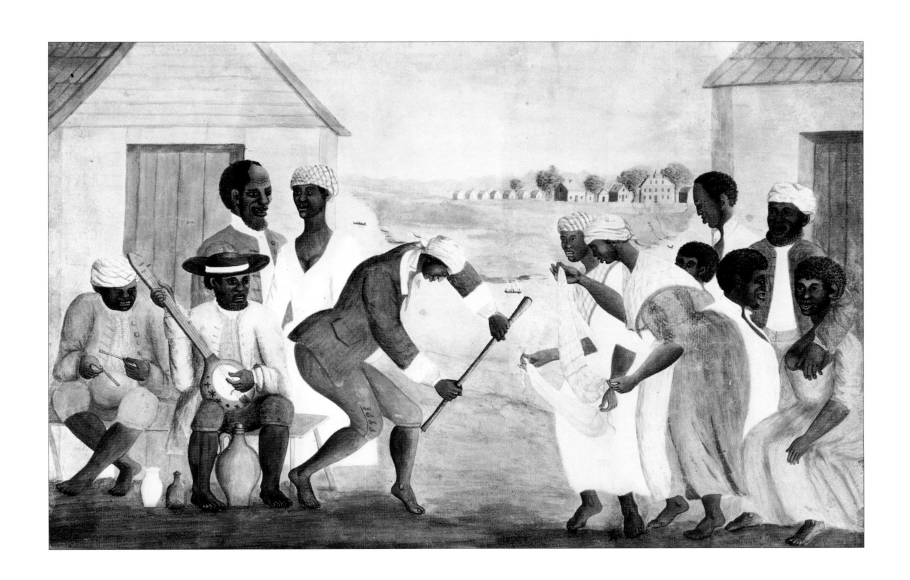

DANTE GABRIEL ROSSETTI

The Bower Meadow

1871–1872

OIL ON CANVAS, 33½" × 26½" (85 × 67.3CM). CITY OF MANCHESTER ART GALLERIES, MANCHESTER, ENGLAND.

The Bower Meadow by English Pre-Raphaelite artist and poet Dante Gabriel Rossetti (1828–1882), began as an exercise in landscape painting "from nature" in 1850, but was never successfully completed. Short of money in 1872, Rossetti took up the partially painted canvas and created the present composition, which is reminiscent of early Italian Renaissance paintings depicting musical angels. In fact, Rossetti so admired Andrea Mantegna's painting *Parnassus* that he wrote a sonnet about it as early as 1849. In *The Bower Meadow*, Rossetti purposefully juxtaposes the coloring of the dresses and hair of the two women dancing in the background with the symmetrical placement and carefully considered gestures of the two women playing musical instruments in the foreground. This is a painting which, in the words of one scholar, "carries no meaning, although it looks as if it might." To the right is an ambiguous structure of semiclassical design that almost appears to be some sort of elaborate birdhouse surrounded by swooping and preening doves, while in the far distance a lone woman mysteriously crosses the green.

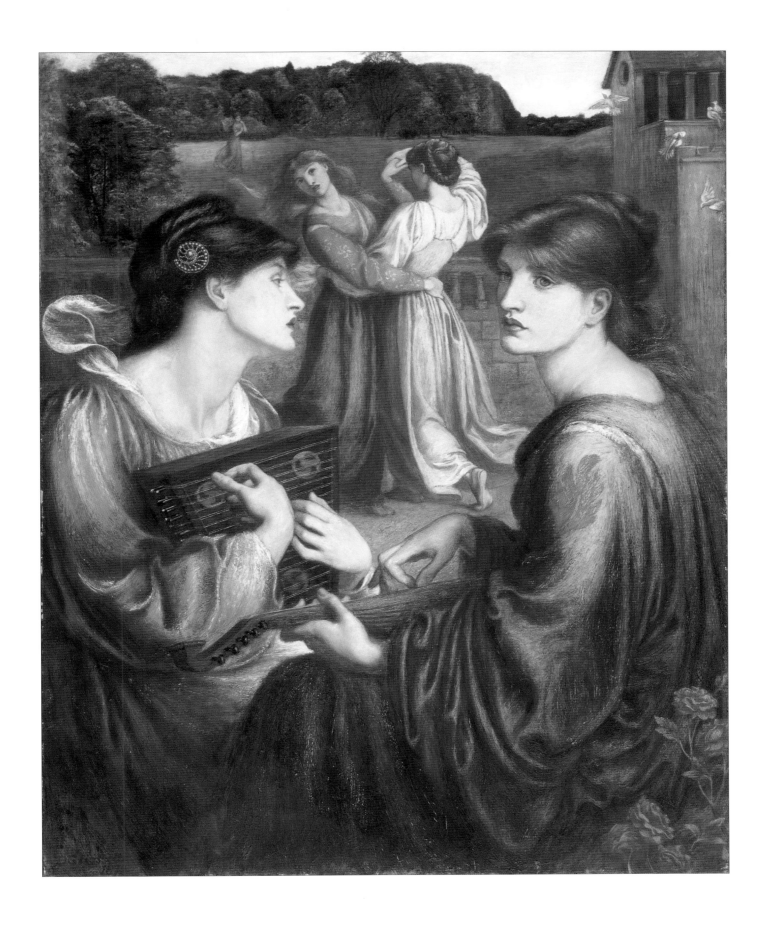

EDGAR DEGAS

Ballet Rehearsal on Stage

1874

OIL ON CANVAS, 25⅜" × 31⅞" (64.4 × 81 CM). MUSÉE D'ORSAY, PARIS.

Edgar Degas' (1834–1917) numerous studies of dancers represent some of his best-known images. *Ballet Rehearsal on Stage* is one of three similar compositions, each produced in different mediums. This version, the largest, was displayed at the first Impressionist exhibition of 1874 before it was donated to the Louvre in 1911. Ernest Chesneau, a contemporary critic, noted: "There is nothing more interesting than this picturesque depiction of the play of light and shadow caused by the glow of stage footlights. M. Degas renders the scene with a charming and delightful attention to detail. He draws in a correct and precise manner, with the sole objective of scrupulous fidelity to the subject....His color, in general, is a little muted." Degas' reputation was based on his exceptional abilities as a draftsman, and this work, painted in grisaille, or monochromatic shades, may have contributed to this belief. In actuality, *Ballet Rehearsal on Stage*, the only documented grisaille painting in Degas' entire work, was probably intended to be used as a model for an engraver. The thin layer of paint reveals pentimenti, the presence of earlier images, and as such is evidence of change in the composition.

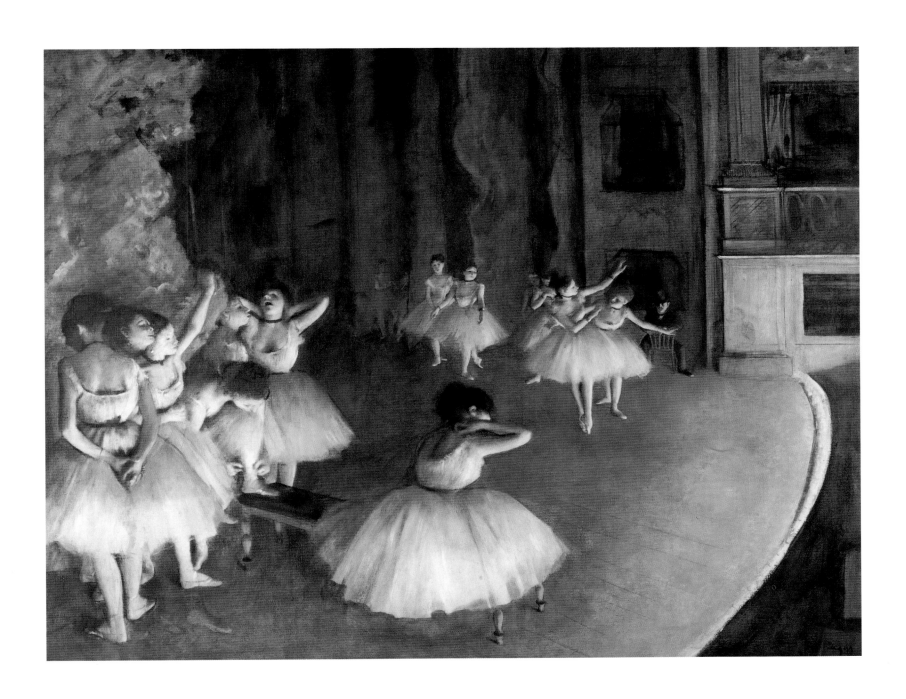

PIERRE-AUGUSTE RENOIR

Dance at the Moulin de la Galette

1876

OIL ON CANVAS, 51½" × 69" (130.8 × 175.2CM). BEQUEST OF GUSTAVE CAILLEBOTTE, 1894. MUSÉE D'ORSAY, PARIS.

*D*ance at the Moulin de la Gallette by Pierre-Auguste Renoir (1841–1919) is one of the most celebrated French Impressionist works. Renoir often spent Sunday afternoons or evenings at the famous public dance hall, observing the spectacle before him. This picture was painted on the grounds of the establishment itself, executed in the plein-air, or out-of-doors, tradition of French Impressionism. Renoir's friends helped carry the canvas to and from the Moulin each day; they even posed for the artist, their partners recruited from the multitude of young women who came to waltz late into the night. Among the dancers represented in the painting are artists Franc-Lamy, Goeneutte, Rivière, Gervex, Cordey, Lestringuez, and Lhote. During this period, Renoir was preoccupied with the study of the momentary effects of natural light and shadow. In this composition, he deliberately places his figures under trees so that they are dappled with spots of sunlight that filter through the foliage, resulting in the irregular pattern of reflections and luminous splotches dispersed throughout the scene. The overall effect is enchanting: Renoir has captured the essence of spontaneity in the capricious gaiety of a crowded Parisian scene.

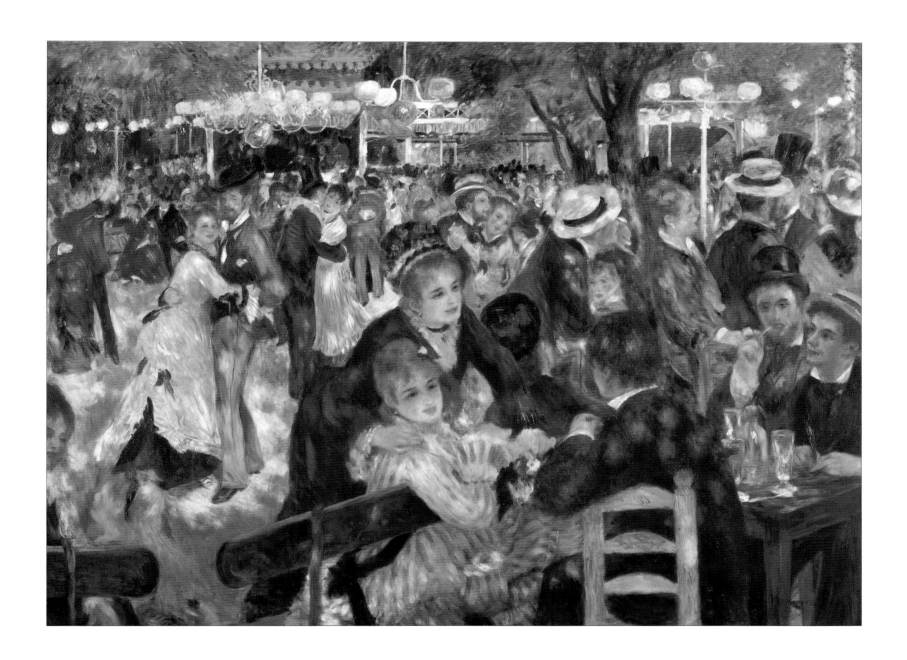

PAUL GAUGUIN

Breton Girls Dancing, Pont-Aven

1888

OIL ON CANVAS, 28⅛" × 36½" (71.4 × 92.7CM). .
COLLECTION OF MR. AND MRS. PAUL MELLON, NATIONAL GALLERY OF ART, WASHINGTON, D.C.

In 1888, Paul Gauguin (1848–1903) wrote to Vincent van Gogh's brother, Theo: "I'm doing a *gavotte bretonne*, three little girls dancing in a hayfield….The painting seems original to me and I'm quite pleased with the composition."

Gauguin was referring to his *Breton Girls Dancing, Pont-Aven*. The painting's site, which Gauguin had used before as a backdrop for earlier works, was called Derout Field, located on the side of a hill behind the church at Pont-Aven, in Brittany, France. Gauguin spent six months there, attempting to "get under the skin of the people and the country," believing this to be "essential in painting." The composition of *Breton Girls Dancing, Pont-Aven* is carefully considered. The slightly awkward positioning of the figures creates a rhythmical zigzag movement, leading the viewer's eye in a sweeping diagonal toward the upper right-hand portion of the canvas. The church bell tower, visible in the background toward the left, balances the composition, acting as a strong vertical anchor. Gauguin's use of color is also effective: the dark dresses of the girls, offset by their crisp, white collars and bonnets, are punctuated by bright red flowers and stand out sharply against the pervasive mustard yellow background.

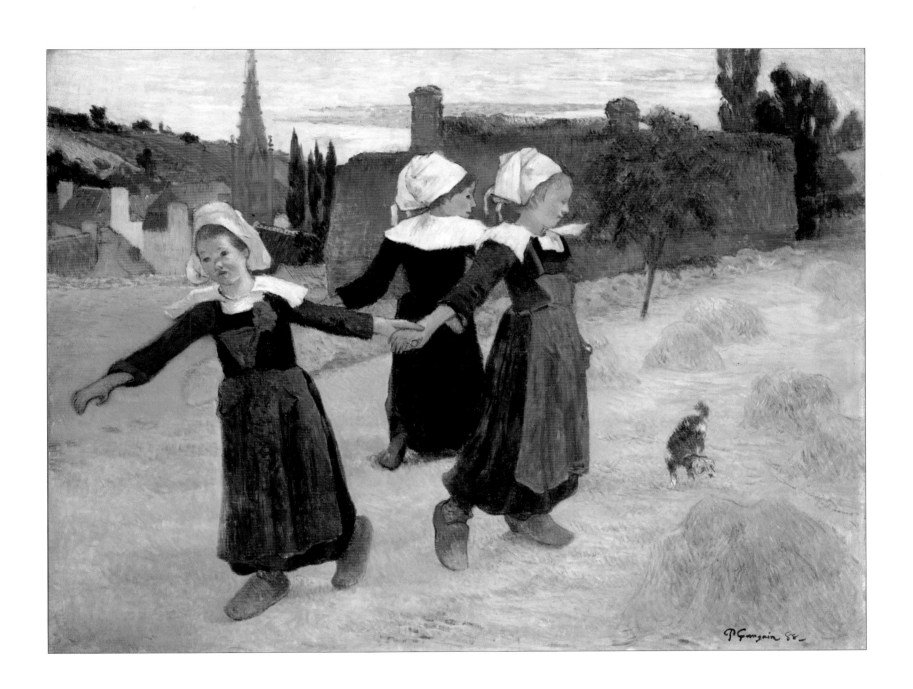

GEORGES SEURAT

Le Chahut

1889–1890

OIL ON CANVAS, 66½" × 55½" (168.9 × 141 CM). RIJKSMUSEUM KRÖLLER-MÜLLER, OTTERLO, THE NETHERLANDS.

Le Chahut by Georges Seurat (1859–1891) was first shown at the exhibition of the Independents in 1890, where it received mixed reviews. "Seurat," Theo van Gogh wrote to his brother, Vincent, "is exhibiting a really curious painting, denoting the effort to express things through the direction of lines. He certainly expresses movement, but his canvas has a rather strange aspect and does not seem to reflect a very generous idea." The picture's subject is the famous cancan, performed at the notorious nightclubs of Montmartre, a bohemian section of Paris that attracted artists, writers, and hordes of tourists. The stylized lineup of dancers has been compared to ancient Egyptian bas-reliefs, which are similar in their repetitive, quasiprofile configuration. The composition is condensed, flattened against the picture plane, including the orchestra in the pit below. Employing his trademark Pointillism, Seurat broke up the color into a series of dots and dashes in accordance with a complicated theory. The color scheme of *Le Chahut* is dominated by red tones, and the many lines and angles of the painting—the legs, shadows, and even the mouths, eyes, and eyebrows—swerve upward, giving the entire scene a buoyant lift appropriate to its subject.

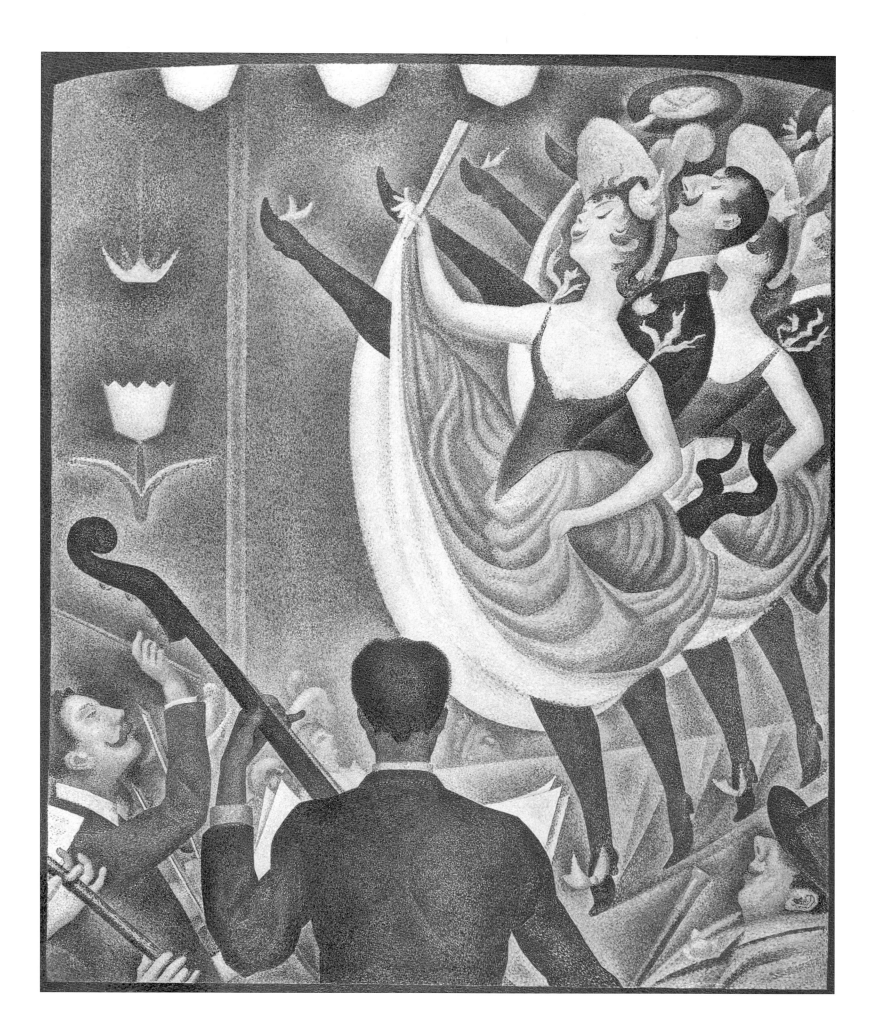

HENRI DE TOULOUSE-LAUTREC

At the Moulin Rouge: The Dance

1889–1890

OIL ON CANVAS, 45¼" × 59⅟₁₆" (115 × 150CM). THE HENRY P. MCILHENNY COLLECTION, IN MEMORY OF FRANCES P. MCILHENNY. PHILADELPHIA MUSEUM OF ART.

No artist has captured the formidable pageantry of Parisian nightlife more instinctively than Henri de Toulouse-Lautrec (1864–1901). Born to aristocracy, Toulouse-Lautrec was a sickly child. After two accidents in which he broke his legs (one each time), his upper body developed, but his legs remained as they were at age thirteen. In view of his crippling deformity, it isn't surprising that Toulouse-Lautrec ultimately found his place among society's lost souls in the city's night spots. His vision was merciless; it combined haughty distance with an outcast's acceptance of human frailty.

At the Moulin Rouge: The Dance features the famous quadrille, performed by an uninhibited young woman kicking up her skirts in a brash display of red stockings, while her partner, Valentin-le-Désosséé (The Boneless), reportedly always wearing his stovepipe hat, dances high on his toes. The colors created by the artificial light are characteristically lurid. Toulouse-Lautrec creates a false sense of depth using the lines of the floorboards, the foreground placement of the two women watching the scene, and the ring of onlookers surrounding the central couple. A captured movement, a chance gesture which seized the essence of the moment, was Lautrec's prime objective in his painting and life.

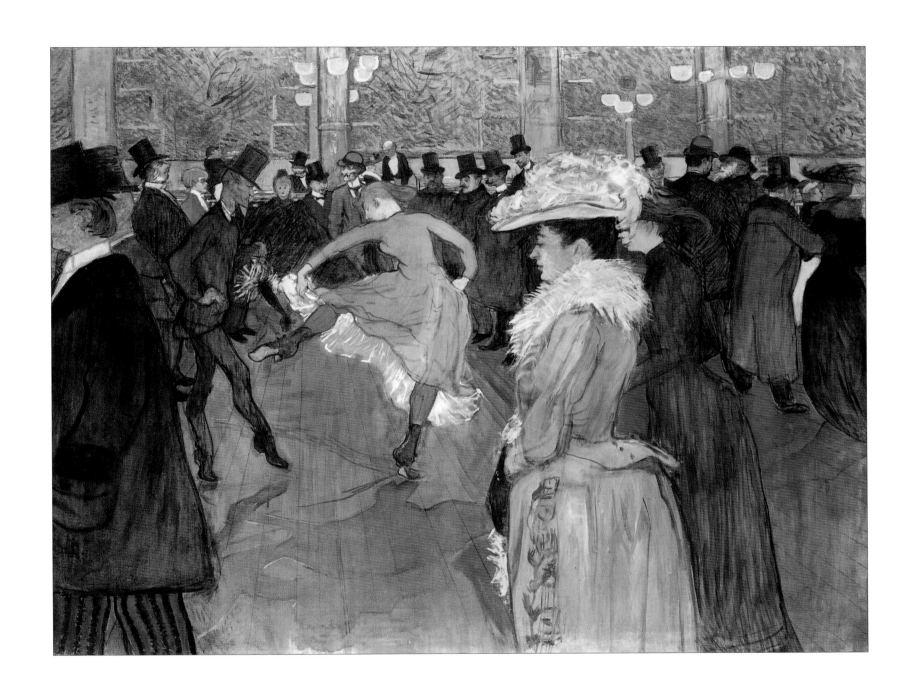

EDVARD MUNCH

The Dance of Life

1899–1900

OIL ON CANVAS, 49³⁄₁₆" × 75³⁄₁₆" (124.9 × 191CM). NASJONALGALLERIET, OSLO, NORWAY.

Norwegian artist Edvard Munch (1863–1944) created a series of works, referred to as the *Frieze of Life*, based on his personal experiences from the 1880s through the next decade. The predominant themes are love, anxiety, and death. *The Dance of Life* is from the *Frieze of Life*'s love cycle, and Munch describes it in his diary: "I am dancing with my true love—a memory of her—a smiling, blond-haired woman enters who wishes to take the flower of love—but it won't allow itself to be taken—and on the other side one can see her dressed in black troubled by the couple dancing—rejected—as I was rejected from her dance." In the scene, Munch, dressed in black, is dancing with a woman in red amid other swirling couples on a lush green lawn by the water. (Munch's partner, his first love, severed their relationship and hurt him profoundly.) On either side of the central pair, who are united by a continuous outline, are two versions of the same woman, one with whom Munch was currently involved. On the left, she is hopeful; on the right, she is disappointed, and in this way expresses Munch's difficulties with their relationship. The painting represents the romantic paradox of Munch's life.

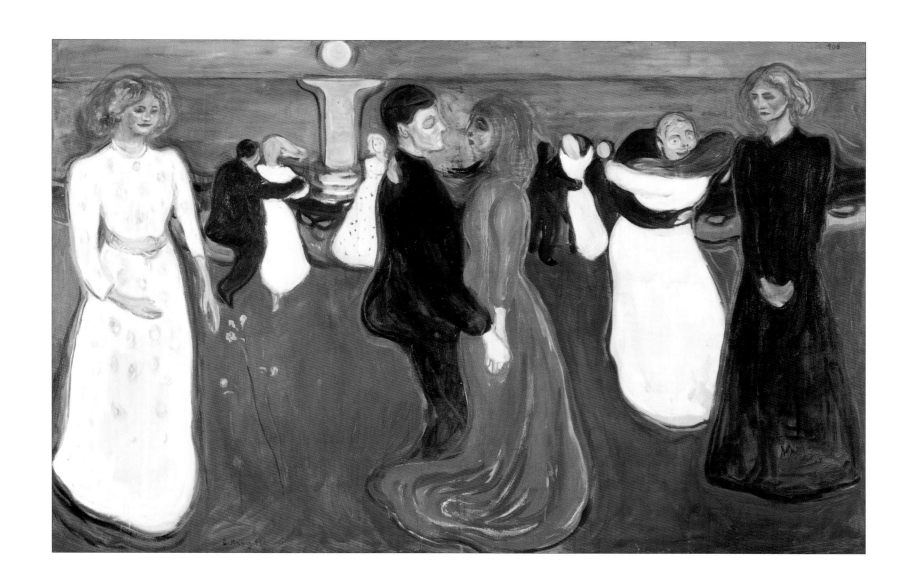

EMIL NOLDE

The Golden Calf

1910

OIL ON CANVAS, 34⅝" × 41½" (87.9 × 105.4CM). STAATSGALERIE MODERNER KUNST, MUNICH.

In the summer of 1909, German Expressionist Emil Nolde (1867–1956) began a series of religious paintings that led him to an artistic epiphany: he opened a new path into the depths of the human psyche, the realm where images are created to symbolize visual and spiritual experiences. Nolde believed that if an artist kept himself open to the power of color and allowed a picture to unfold spontaneously, he would more likely discover it in the literal sense of the word. This idea reinforced his conviction that "instinct is ten times what knowledge is." Guided by this instinct, Nolde applied paint with anything within his reach—brushes, pieces of cardboard, even his fingers. *The Golden Calf* clearly illustrates Nolde's extreme style. The brushwork and intensity of the colors is unrestrained and fierce, contributing to the ecstatic frenzy of the scene. Nolde associated dance with the untamed, savage, and orgiastic. The implied rhythm of the figures' stamping legs and swaying arms is wild and primal. Behind the four dancing worshipers, who are in various states of undress, is the object of their idolatry: a golden calf, which glistens from the heat and light of a surrounding sacrificial fire.

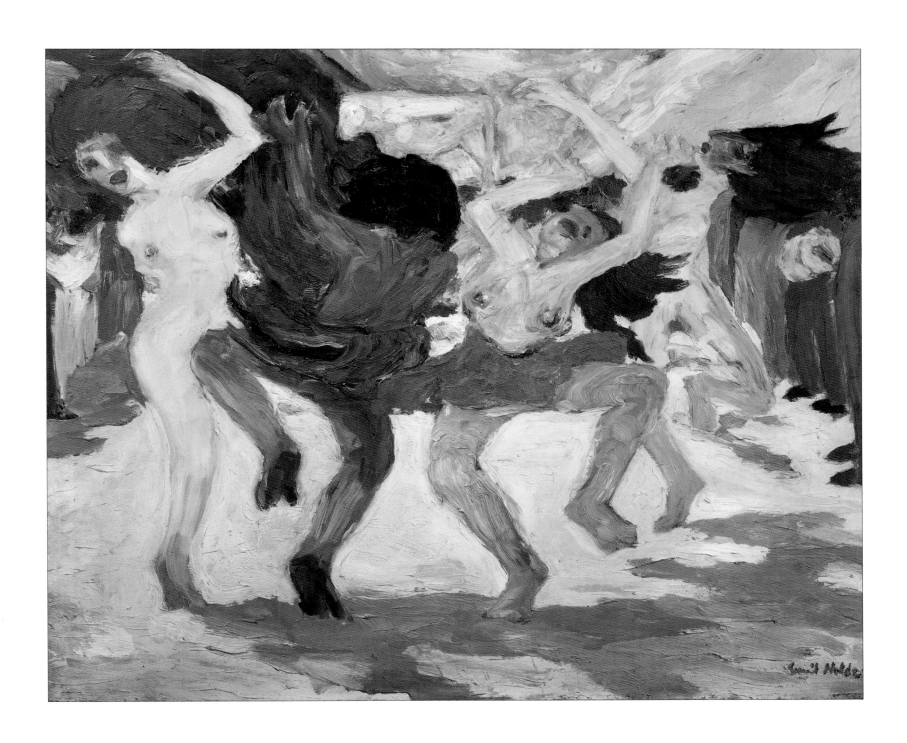

LÉON BAKST

Faun

1912

GOUACHE, WATERCOLOR AND GOLD ON PAPER MOUNTED ON CARDBOARD, 15⁵⁄₁₆" × 10¹¹⁄₁₆" (38.8 × 27.1 CM).
WADSWORTH ATHENEUM, HARTFORD, CONNECTICUT.

Little of Léon Bakst's (1866–1924) personal life was documented while he was alive. The quixotic Russian artist's career, which began in St. Petersburg, culminated in 1909 with the formation of the Ballets Russes and his collaboration with the producer Sergei Diaghilev. Later on Bakst would apply his talents to the fields of interior design and fashion. A painter as well as a set and costume designer, Bakst was a driving force behind the Ballets Russes, a company which attracted some of the twentieth century's most imaginative artists, such as composer Igor Stravinsky, dancer and chore-ographer Vaslav Nijinsky, and artists Pablo Picasso and Jean Cocteau. *Faun* is the design Bakst executed for Nijinsky's costume in *Prélude à L'Après-midi d'un Faune*, the ballet based on Debussy's musical composition of the same name. Bakst created all the sets and costumes, determined all the performers' makeup, and helped choreograph the dance. Bakst's extravagant paintings visually capture the ultimate fantasy of ballet, yet are distinctive, exotic works of art.

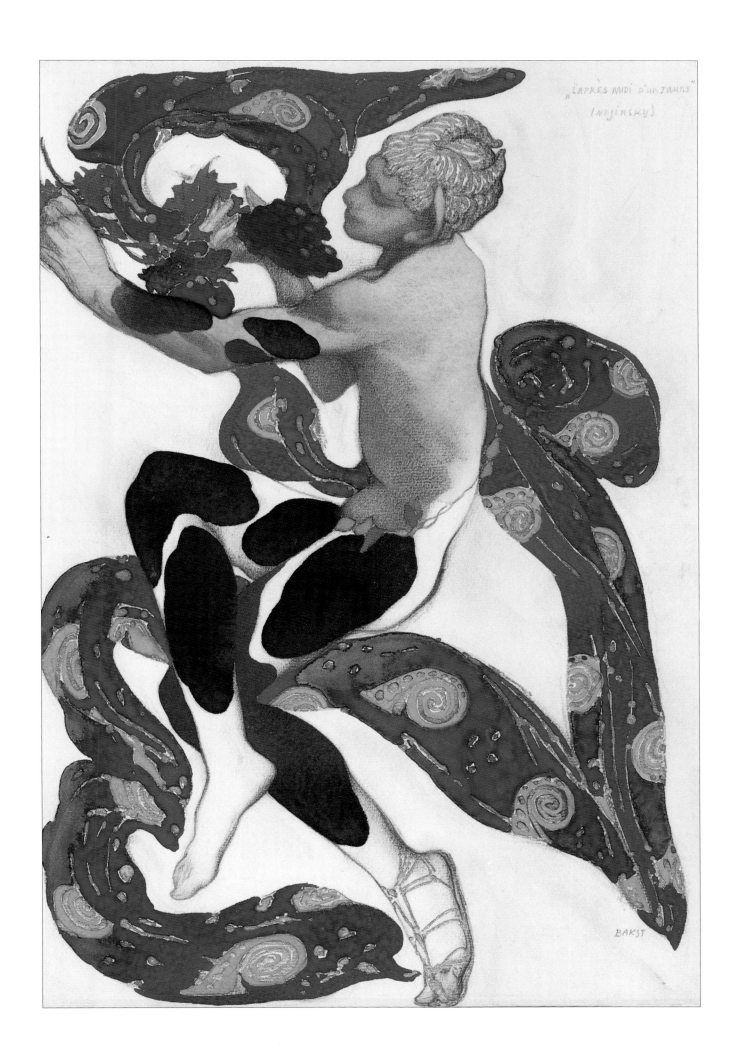

GINO SEVERINI

Dynamic Hieroglyph of the Bal Tabarin

1912

OIL ON CANVAS, WITH SEQUINS, 63⅝" × 61½" (161.6 × 156.2CM). THE MUSEUM OF MODERN ART, NEW YORK.

Italian painter Gino Severini (1883–1966) is associated with the short-lived but influential Italian art movement Futurism (1909–1916), which extolled a new approach to art based on the theory that speed was the dynamic and fundamental element of modern life. In 1913 Severini wrote: "We choose to concentrate our attention on things in motion, because our modern sensibility is particularly qualified to grasp the idea of speed. Heavy, powerful motor-cars rushing through the streets of our cities, dancers reflected in the fairy ambience of light and color, airplanes flying above the heads of the excited throng…these sources of emotion satisfy our sense of a lyric and dramatic universe…" The dancers Severini mentioned probably refer to his most acclaimed painting, *Dynamic Hieroglyph of the Bal Tabarin*. A resident of Paris, Severini turned his Futurist spin on the dance scenes of Toulouse-Lautrec and Seurat. The floridly patterned painting, complete with sequins, scintillates with motion in a joyous burst of energy. Oscillating between abstraction and representation, the painting offers coy visual clues to the viewer, such as a monocle, a mustache, a high heel, and a ruffled maroon petticoat—with words like *valse* ("waltz") and polka thrown in for good measure.

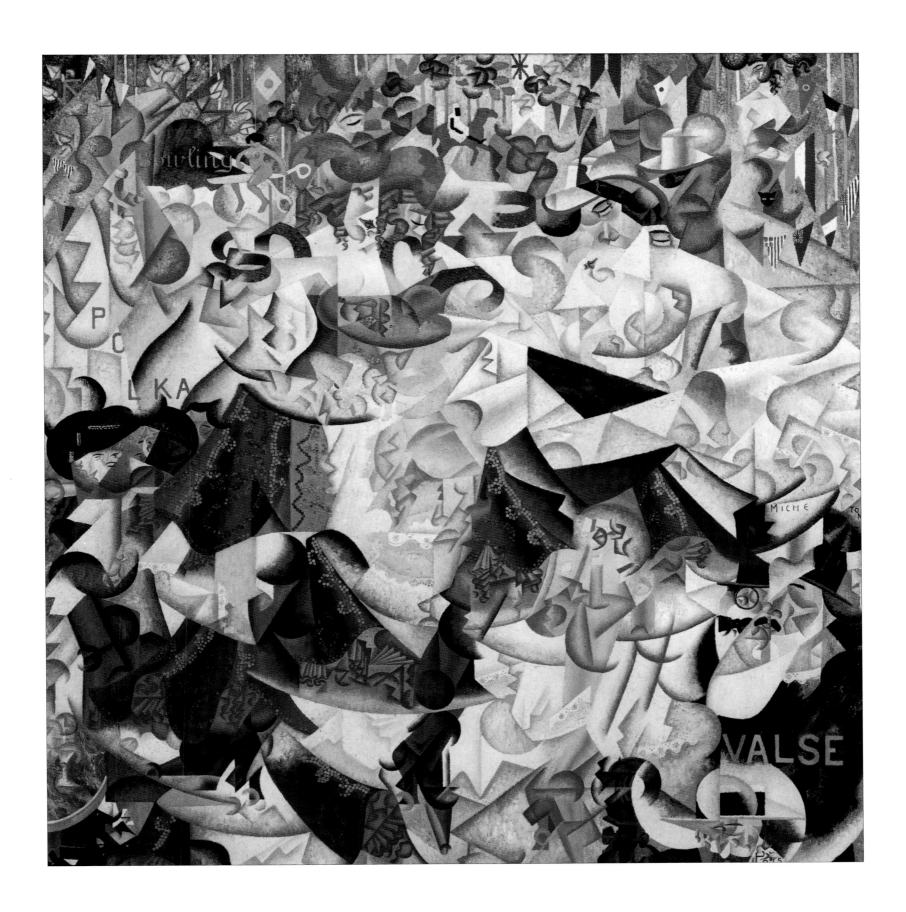

CHARLES DEMUTH

Vaudeville

1917

WATERCOLOR AND PENCIL ON PAPER, 8" × 10½" (20.3 × 26.6CM). KATHARINE CORNELL FUND.
THE MUSEUM OF MODERN ART, NEW YORK.

Charles Demuth (1883–1935) studied at the distinguished Pennsylvania Academy in Philadelphia, where he received instruction from Thomas Anschutz, who had taught a long list of reputable artists like Robert Henri, John Sloan, William Glackens, and George Luks. In the twenties, Demuth became involved with Precisionism, a movement comprised of artists, writers, and photographers whose work glorified the American machine age. Demuth's paintings of industrial and architectural sites are among the group's finest works. Although Demuth worked in a number of mediums, he is perhaps best known for his exquisite watercolor paintings, of which he produced a great number. He specialized in flower studies and still lifes, as well as in scenes from the vaudeville stage, the circus, and genre portraits of New York's Greenwich Village bohemian scene. In 1914 Demuth moved to the Village, where he frequented its many cafes and nightclubs. *Vaudeville* is a typical work from this period; the broad swinging figures of the three performers swaggering in line stand out dramatically against the wavy, textured backdrop. Without any concrete spatial references, the three dancers seem capable of strolling in tempo indefinitely.

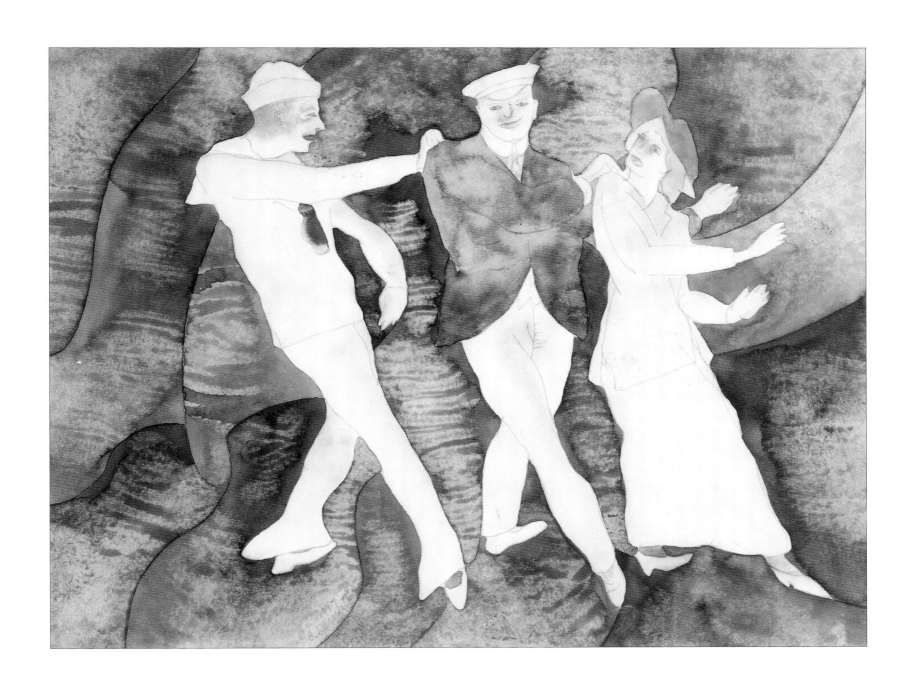

MAX BECKMANN

Dancing Bar in Baden-Baden

1923

OIL ON CANVAS, 39⅜" × 25⅝" (100 × 65CM). GUNTHER FRANKE COLLECTION, BAYERISCHE STAATGEMALDESAMMLUNGEN, MUNICH.

Max Beckmann (1884–1950) was one of a group of German artists during the twenties who followed a philosophy of art called *Neue Sachlichkeit*, or the "New Objectivity." Describing "transcendental objectivity" as the principle of his art, he attempted to find the mythic order, or meaning, beneath the seemingly random nature of everyday occurrences. In his painting *Dancing Bar in Baden-Baden*, Beckmann puts his theory into play. Clearly, to the artist, the underlying essence of these elegantly attired couples with their cultured facades reeks of decadence. To dramatize his disdain for the showy display of wealth and questionable taste of these "upper-crust" individuals, Beckmann employed garish iridescent colors that are almost painful to look at. At the same time, Beckmann seems amused by the posturing attitudes of his subjects, and depicts them as being rather silly and harmless. The compact composition is cleverly organized by a rhythmic pattern of parallel arms and hands that points out the direction of the dancers' movement. The repetition of lines and angles in the tight pictorial space makes for an amusing, if claustrophobic, visual statement.

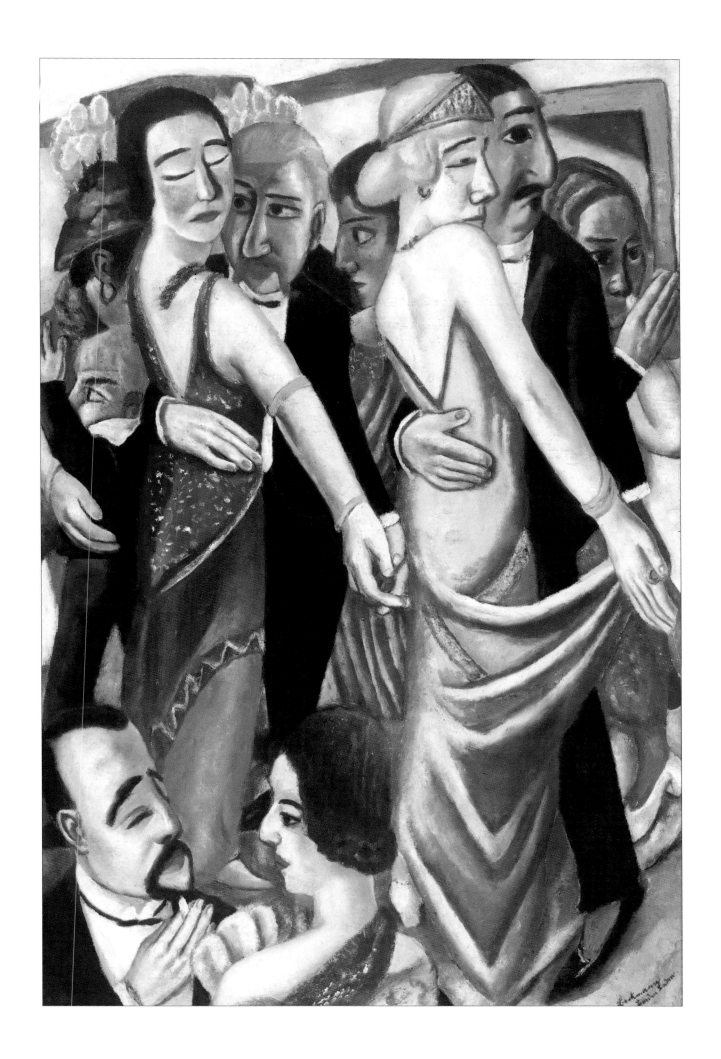

REGINALD MARSH

Minsky's Chorus

1935

Tempera on composition board, 29¾" × 35⅞" (75.5 × 91.1 cm).
Partial and promised gift of Mr. and Mrs. Albert Hackett in honor of Edith and Lloyd Goodrich, P. S. 83.
The Whitney Museum of American Art, New York.

During the Great Depression, American painter Reginald Marsh (1898–1954) roamed the streets of New York City, joining the throngs of frustrated men and women who went out walking in search of some relief from their problems. Everywhere he went, Marsh sketched the sights and the action of the restless city in his pocket notebook. His was a world of sailors and derelicts, prostitutes and dance-hall girls. He rode the elevated or subway out to Coney Island, returned to Manhattan for lunch at Sloppy Louie's on Fulton Street, and would inevitably take in a burlesque show. The theater offered Marsh the opportunity to observe the body in motion within a structured setting of carefully ordered ritual. *Minsky's Chorus* is presented from a spectator's vantage point. The surreal lighting makes the strutting dancers appear harsh, as it exaggerates their pasty complexions as they bump and grind their way through their number. The automatonlike dancers are well built but untouchable, and stand in complete contrast to the two middle-aged men in the audience who survey the scene with restraint and decorum.

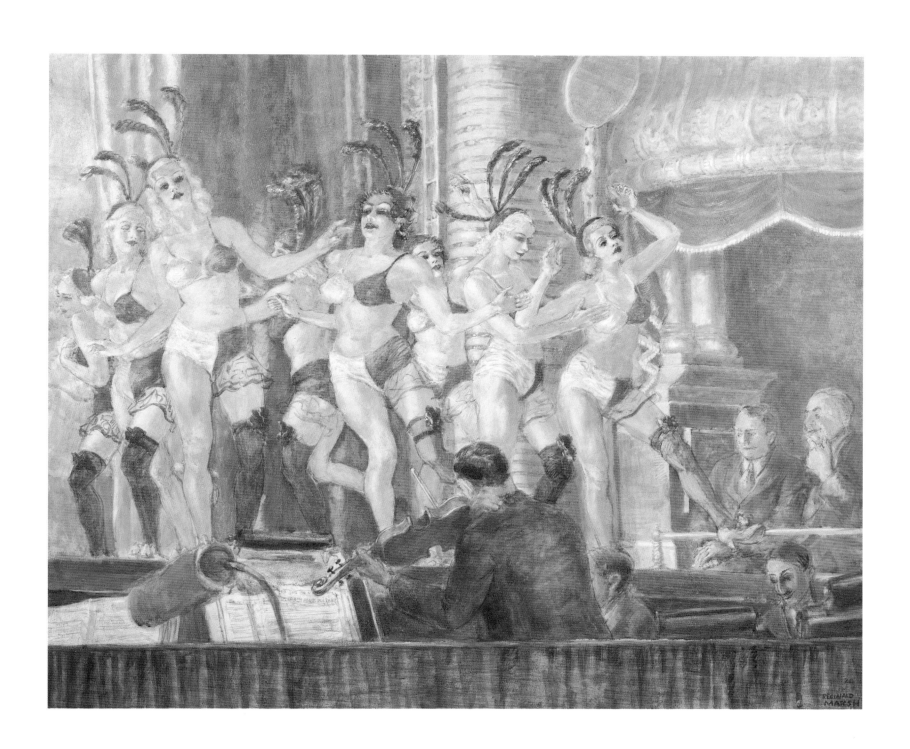

DIEGO RIVERA

Baille en Tehuantepec

1935

CHARCOAL AND WATERCOLOR ON PAPER, 18¹⁵⁄₁₆" × 23⅞" (48.1 × 60.6CM).
GIFT OF MILTON W. LIPPER FROM THE MILTON W. LIPPER ESTATE. LOS ANGELES COUNTY MUSEUM OF ART.

The 1933 Mexican artist Diego Rivera (1886–1957) returned to his homeland after spending a period of successful but controversial years in America. In his autobiography, he recalled: "My homecoming produced an aesthetic exhilaration which it is impossible to describe. It was as if I were being born anew, born in a new world…where forms and colors existed in absolute purity. In everything I saw a potential masterpiece—the crowds, the markets, the festivals." Little attention has been paid to Rivera's easel paintings and drawings, which he produced throughout his career, as he is revered as one of the twentieth century's foremost Social-Realist muralists. *Baile en Tehuantepec* is an exhuberant watercolor, one from a series of Tehuantepec themes Rivera produced in 1935. Shown here is the *zandunga,* a popular folk dance in the region of southern Mexico. The couples dance barefoot with considerable poise. The women, their hair elaborately braided, hold out their dresses with one hand, while the men move about them in a modest room. Against the back wall, a row of seated women await their turn to dance. Rivera's colors are bright and vibrant, reflecting the richness of his country's artistic and cultural heritage.

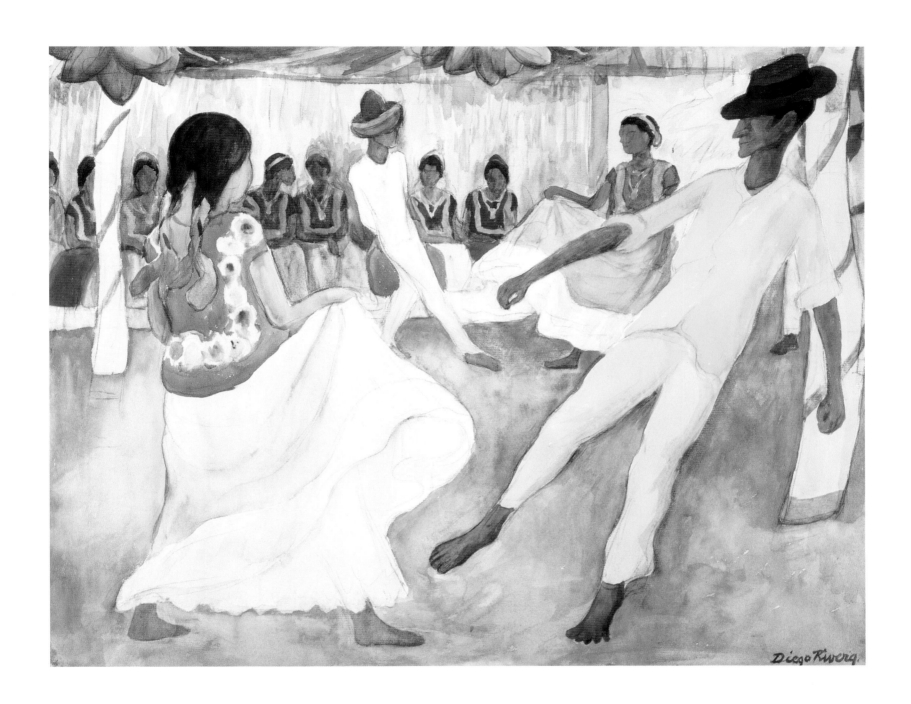

FRANCIS PICABIA

Printemps

c. 1937–1943

OIL ON PLYWOOD, 58⅜" × 37⅜" (148.2 × 94.9CM). THE MENIL COLLECTION, HOUSTON, TEXAS.

Francis Picabia (1897–1953) was a key figure in the Dada art movement, in which convention and middle-class artistic standards were derided in an effort to reach a more authentic aesthetic reality. The guiding principles of Dada were chance, intuition, and irrationality. Bearing this in mind, the story of *Printemps* is especially appropriate. Picabia's friend Henri Goetz was awakened in 1943 by the cries of Picabia's wife, Olga, who begged him to rush to her husband's studio. Upon arriving, he found Picabia painting flowers all over his canvases. Picabia explained to Goetz that he felt elated on this beautiful spring day and was enjoying himself immensely by painting daisies all over everything. It is uncertain but likely that *Printemps* is one of Picabia's vernal casualties. X-rays have revealed that the painting results from a process of creation, destruction, and re-creation. The work originated as a bluish canvas c. 1935–1937, evidenced by leftover patches of color in the dancing figures. A second abstract painting was discovered underneath, which was completely obliterated in 1938 by the third version, that of the the dancing couple. Finally, the flowers and dots were added impulsively on that fortuitous spring morning in 1943.

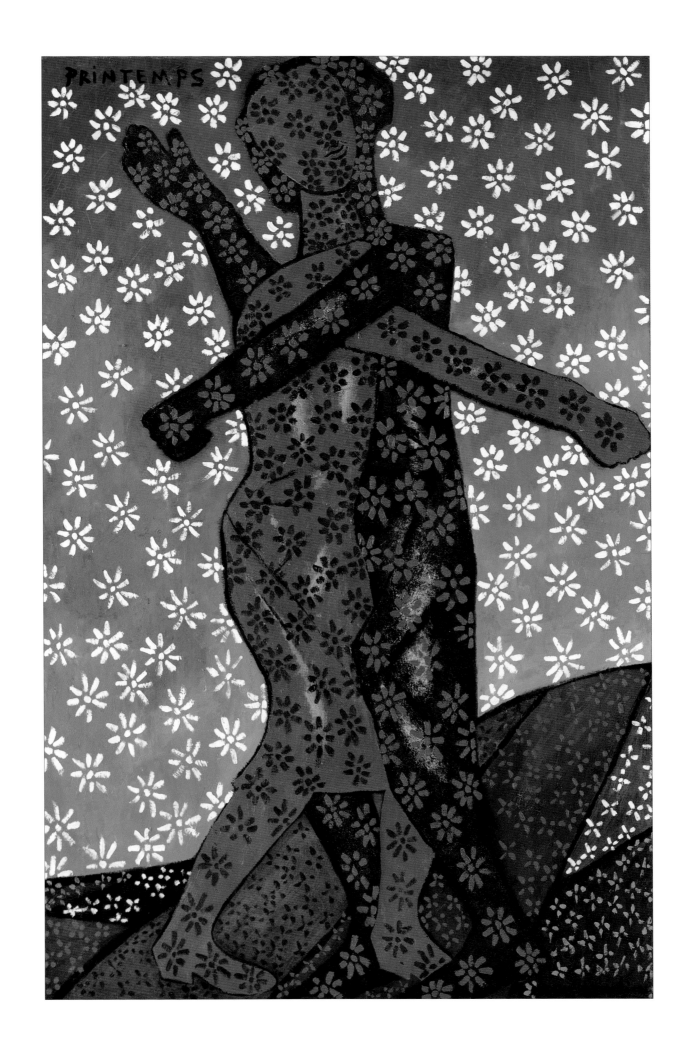

JAMES ROSENQUIST

The Promenade of Merce Cunningham

1963

OIL ON CANVAS, 60"×70" (152.4×177.8CM). THE MENIL COLLECTION, HOUSTON, TEXAS.

In 1962 James Rosenquist (b. 1933) had his first one-man show in New York City. Eleven out of the exhibition's twelve paintings were sold before the gallery doors opened. This unqualified success rocketed Rosenquist to the top ranks of the Pop Art scene. Rosenquist's subjects, gargantuan scale, wide-angle vision, and technique were cultured from years of outdoor billboard painting. The commercial billboard images were realistic from a distance but disintegrated into abstraction when viewed close-up. This altered Rosenquist's thinking and led him to "make pictures of fragments, images that would spill off the canvas instead of recede into it....I thought I would paint them as realistically as possible. Then I thought about the kind of imagery I'd use. I didn't want anything brand new [or] anything antique either.... I wanted to find images that were in a 'nether-nether-land,' things that were a little out of style, but hadn't reached the point of nostalgia." Rosenquist works from small-scale collages, which he then blows up into monumental paintings. *The Promenade of Merce Cunningham* is composed of three unrelated clippings. The incongruous imagery of enormous proportions creates something mysterious out of the mundane.

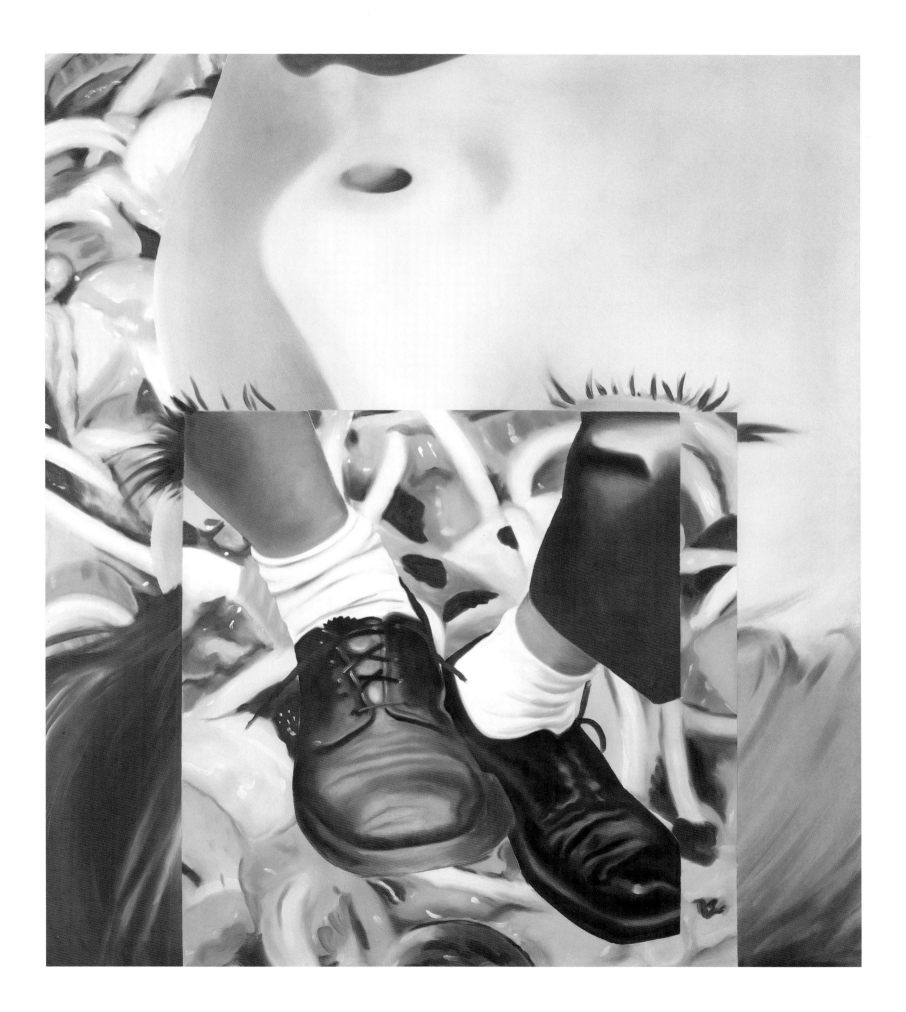

ROY LICHTENSTEIN

Artist's Studio, the "Dance"

1974

OIL AND MAGNA ON CANVAS, 96⅛" × 128⅛" (244.1 × 325.4CM).
GIFT OF MR. AND MRS. S.I. NEWHOUSE, JR. THE MUSEUM OF MODERN ART, NEW YORK.

The paintings of Roy Lichtenstein (b. 1923) are immediately recognizable. In 1961 he developed his iconic Pop idiom: using the Benday dot photoreproduction process, Lichtenstein created large-scale paintings of comic-strip panels and consumer-product advertising images, which epitomize the blatantly representational and kitsch approach of the Pop movement. Throughout his successful artistic career he has continued to explore and experiment with potential applications of his individualized style to more intellectually challenging and far-reaching projects. From 1972 to 1974, Lichtenstein produced a series of studio interior paintings that made specific reference to the work of Henri Matisse.

Artist's Studio, the "Dance" is based on Matisse's Still Life with the "Dance" (1909). Lichtenstein, however, has manipulated Matisse's composition and included still-life elements of his own, like the Chianti bottle and the piece of driftwood lying on the table. He has also inserted a portion of one of his own earlier paintings, Sound of Music (1964), the sliver of canvas with flowing musical notes whose window frame both relates to the rectangular framing elements of the original Matisse and punningly provides musical accompaniment for the dancers.

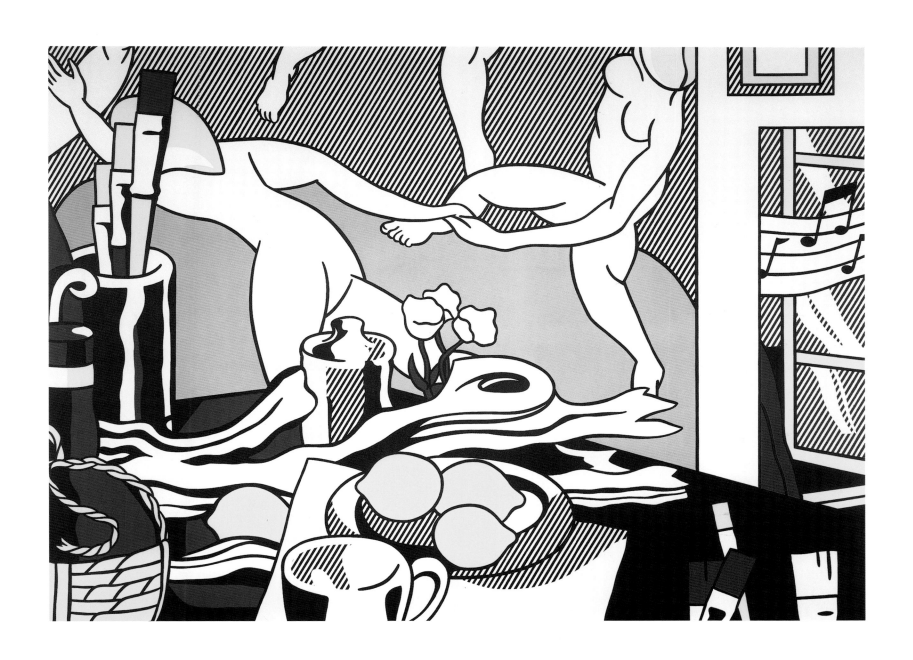

JASPER JOHNS

Dancers on a Plane

1980

OIL ON CANVAS, 78⅜" × 63¾" (199 × 161.9CM) INCLUDING PAINTED BRONZE FRAME, TATE GALLERY, LONDON.

Following the existential works of Abstract Expressionists like Jackson Pollock and Robert Motherwell, Jasper Johns'

(b. 1930) formal paintings of literal, seemingly banal imagery were strikingly different. In 1960 Johns created a sculp-

ture called *Painted Bronze*, which was in the form of two Ballantine Ale cans. This and other deliberately nonintrospec-

tive works provoked some critics to label him as a precursor to Pop Art. But in fact, Jasper Johns is an artist who has

moved through various forms of expression. The *Dancers on a Plane* series developed out of his "hatch-mark" paintings

of the seventies. *Dancers on a Plane* is one of three paintings of the same title, two of which make a pair. This 1980 ver-

sion is the largest of the three works and evokes the darkest feeling. Typical of John's work is the integration of three-

dimensional objects into the composition: here, forks, knives, and spoons complement the rhythmic movement of the

various cross-hatched patterns. The dancer in the painting is implied by the title, which makes reference to both the

artist's picture plane and the dancer's surface plane.

PHOTOGRAPHY CREDITS

Henri Matisse, *Dance* (first version), 1909, oil on canvas, 102½" × 153½" (259.7 × 390.1cm), The Museum of Modern Art, NY

Master of the Prayer Books, *Dance of Mirth*, Harley Manuscript 4425, folio 14v in Guillaume de Lorris and Jean de Meun's *Roman de la Rose*, c. 1490–1500, ink and colors on vellum, 15½" × 11½" (39.4 × 29.2cm). By permission of the British Library, London

Winslow Homer, *A Summer Night*, 1890, oil on canvas, 29½" × 39¾" (75 × 101cm), Musée d'Orsay, Paris. Photo: Erich Lessing/Art Resource, NY

Edgar Degas, *Blue Dancers*, 1890, oil on canvas, 33½" × 29¼" (85 × 75.5cm), Musée d'Orsay, Paris. Photo: Erich Lessing/Art Resource, NY

Andrea Mantegna, *Parnassus*, 1496, oil on canvas, 59ⁱ⁄₁₆" × 75⁵⁄₁₆" (150 × 192cm), Musée du Louvre, Paris. Photo: R.M.N., Paris

Sandro Botticelli, *Mystic Nativity*, c. 1500, oil on canvas, 42¹¹⁄₁₆" × 29½" (108.5 × 75cm). National Gallery, London

Pieter Brueghel the Elder, *The Wedding Dance*, 1566, oil on panel, 47" × 62" (119.4 × 157.5cm). Photo: ©The Detroit Institute of Arts, City of Detroit Purchase

Unknown, *A Ball at the Court of Henri III*, c. 1582, oil on canvas, 47¼" × 72¼" (120 × 183.5cm), Musée du Louvre, Paris. Photo: R.M.N., Paris

Peter Paul Rubens, *Dance of the Villagers*, c. 1636, oil on panel, 28¾" × 41¾" (73 × 106cm), Museo del Prado, Madrid

Nicolas Poussin, *The Dance of Human Life*, c. 1638–1640, oil on canvas, 32¾" × 41⅜" (83.3 × 105.1cm), Wallace Collection, London. Photo: Bridgeman/Art Resource, NY

Jan Steen, *The Dancing Couple*, 1663, oil on canvas, 40⅜" × 56¼" (102.5 × 142.5cm), Widener Collection, © Board of Trustees, National Gallery of Art, Washington, D.C.

Nicolas Lancret, *Quadrille Before an Arbor*, c. 1730–1735, oil on canvas, 51⅛" × 38⅜" (130 × 97.5cm), Staatliche Schlösser und Garten, Charlottenburg, Berlin. Photo: Jorg P. Anders

Francis Hayman, *The Milkmaid's Garland*, c. 1740, oil on canvas, 54" × 94½" (137.1 × 240cm), Victoria and Albert Museum, London/Art Resource, NY

Giandomenico Tiepolo, *The Minuet*, 1756, oil on canvas, 30⅞" × 43¹¹⁄₁₆" (78.5 × 111cm), Museu d'Art de Catalunya, Barcelona

Francisco de Goya y Lucientes, *Blind Man's Bluff*, 1788–1789, oil on canvas, 105⅞" × 137¾" (269 × 350cm), Museo del Prado, Madrid. Photo: Scala/Art Resource, NY

Unknown, *The Old Plantation*, c. 1790, watercolor on laid paper, 11¹¹⁄₁₆" × 17⅞" (29.7 × 45.4cm), Abby Aldrich Rockefeller Folk Art Center, Williamsburg, VA

Dante Gabriel Rosetti, *The Bower Meadow*, 1871–1872, oil on canvas, 33½" × 26½" (85.1 × 67.3cm), Manchester City Art Gallery, Manchester, England. Photo: Bridgeman/Art Resource, NY

Edgar Degas, *Ballet Rehearsal on Stage*, 1874, oil on canvas, 25⅜" × 31⅞" (65 × 81cm), Musée d'Orsay, Paris. Photo: Erich Lessing/Art Resource, NY

Pierre-Auguste Renoir, *Dance at the Moulin de la Galette*, 1876, oil on canvas, 51½" × 69" (130.8 × 175.3cm), Musée d'Orsay, Paris, Bequest of Gustave Caillebotte (1894). Photo: Giraudon/Art Resource, NY

Paul Gauguin, *Breton Girls Dancing, Pont-Aven*, 1888, oil on canvas, 28⅛" × 36½" (71.4 × 92.8cm), collection of Mr. and Mrs. Paul Mellon, National Gallery of Art, Washington, D.C.

Georges Seurat, *Le Chahut*, 1889–1890, oil on canvas, 66½" × 55½" (168.9 × 141cm), Rijksmuseum Kröller-Müller, Otterlo, the Netherlands

Henri de Toulouse-Lautrec, *At the Moulin Rouge: The Dance*, 1890, oil on canvas, 45¼" × 59¹⁄₁₆" (115 × 150cm), Philadelphia Museum of Art: The Henry P. McIlhenny Collection in memory of Frances P. McIlhenny

Edvard Munch, *The Dance of Life*, 1899–1900, oil on canvas, 49³⁄₁₆" × 75³⁄₁₆" (125 × 191cm), Nasjonalgalleriet, Oslo, Norway. Photo: Scala/Art Resource, NY

Emil Nolde, *The Golden Calf*, 1910, oil on canvas, 34⅝" × 41½" (88 × 105.5cm), Staatsgalerie Moderner Kunst, Munich, Germany. Photo: Giraudon/Art Resource, NY

Léon Bakst, *Faun*, 1912, gouache, watercolor, and gold on paper mounted on cardboard, 15⅝" × 10¹¹⁄₁₆" (38.9 × 27.2cm), Wadsworth Atheneum, Hartford, Connecticut: Ella Gallup Sumner and Mary Catlin Sumner Collection

Gino Severini, *Dynamic Hieroglyphic of the Bal Tabarin*, 1912, oil on canvas, with sequins, 63⅝" × 61½" (161.6 × 156.2cm), The Museum of Modern Art, NY

Charles Demuth, *Vaudeville*, 1917, watercolor and pencil on paper, 8" × 10½" (20.3 × 26.7cm), The Museum of Modern Art, NY

Max Beckmann, *Dancing Bar in Baden-Baden*, 1923, oil on canvas, 39⅜" × 25⅝" (100 × 65cm), Bayerisches Staatgemaldesammlungen, Munich, Germany: Gunther Franke Collection/Artothek

Reginald Marsh, *Minsky's Chorus*, 1935, tempera on composition board, 29¾" × 35⅞" (75.6 × 91.2cm), The Whitney Museum of American Art, NY: Partial and promised gift of Mr. and Mrs. Albert Hackett in honor of Edith and Lloyd Goodrich. Photo: Geoffrey Clements

Diego Rivera, *Baile en Tehuantepec*, 1935, charcoal and watercolor on paper, 18¾" × 23¾" (47.6 × 60.3cm), Los Angeles County Museum of Art, Gift of Milton W. Lipper Estate

Francis Picabia, *Printemps* (Spring), c. 1937–1943, oil on plywood, 58⅜" × 37⅜" (148.3 × 95cm), The Menil Collection, Houston. Photo: Hickey-Robertson, Houston

James Rosenquist, *The Promenade of Merce Cunningham*, 1963, oil on canvas, 60" × 70" (152.4 × 177.8cm), The Menil Collection, Houston. Photo: Eric Pollitzer, NY

Roy Lichtenstein, *Artist's Studio*, "The Dance," 1974, oil and magna on canvas, 96⅛" × 128⅛" (244.1 × 325.4cm), The Museum of Modern Art, NY, Gift of Mr. and Mrs. S.I. Newhouse, Jr.

Jasper Johns, *Dancers on a Plane*, 1980, oil on canvas including painted bronze frame, 78⅜" × 63¾" (199.1 × 161.9cm), Tate Gallery, London/Art Resource, NY. ©VAGA, NY